IMAGES
of America

SAN MARCO

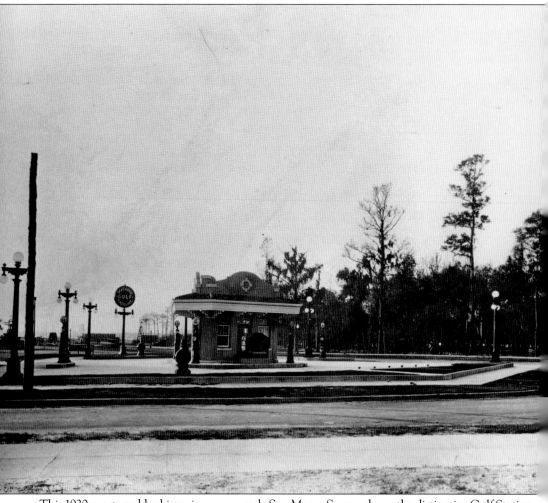

This 1920s westward-looking view across early San Marco Square shows the distinctive Gulf Station building portrayed in the cover photograph. Little of the square had been built at this time, and the station appears isolated on its own island. (Courtesy of State of Florida Archives.)

IMAGES
of America

SAN MARCO

Debra Webb Rogers

Debra Webb Rogers

ARCADIA
PUBLISHING

Published by Arcadia Publishing
Charleston, South Carolina

Printed in the United States of America

Library of Congress Control Number: 2010923944

For all general information, please contact Arcadia Publishing:
Telephone 843-853-2070
Fax 843-853-0044
E-mail sales@arcadiapublishing.com
For customer service and orders:
Toll-Free 1-888-313-2665

Visit us on the Internet at www.arcadiapublishing.com

*To Judy, Merilyn, and Polly, in appreciation for
their help, inspiration, and friendship*

CONTENTS

Acknowledgments 6

Introduction 7

1. Early Days: Plantations and Pioneers 11

2. Decades before Disney: Dreams in South Jacksonville 31

3. South Jacksonville Days: People and Places 53

4. A Vision of Venice: San Marco is Born 73

5. Southbank's Changing Face: Yesterday and Today 97

6. Vanishings and New Beginnings: San Marco Then and Now 113

ACKNOWLEDGMENTS

A book such as this requires the efforts and generosity of many individuals, and without their assistance, this publication would not have been possible. I would like to thank the following people for their contributions and support:

Lindsay Harris, Acquisitions Editor, Arcadia Publishing

Judy and Mike Downs

Laura and Mike of Stan's Sandwich Shop

Merilyn Kaufman, Historian, St. Paul's Episcopal Church

Polly Gray, Librarian, St. Paul's Episcopal Church

Raymond W. Neal, Senior Librarian, Florida Collection, Jacksonville Public Library

Andy Barmer, Librarian, Florida Collection, Jacksonville Public Library

Margaret Morford, Librarian, Florida Collection, Jacksonville Public Library

Jan, Mike and Desiree Bailey, San Marco Bookstore

Barbara Puckett, Director Emeritus of the San Marco Preservation Society

Sharon Laird, Jacksonville Historical Society

N. Adam Watson, Photographic Archivist, State Archives of Florida

Margaret Weatherby

Bill and Margot Bonner

Doris Chappell

Donald Sloneker

Jim Montgomery and the South Jacksonville Presbyterian Church

Terrell Bowman

Robert Williams

Samuel J. Rogers

Pauline D. Webb

Dennis Price

Stevie Rutter

Liz Renn

Pulido's Automotive

Christy Leonard of the Jacksonville Museum of Science and History

Ken Ferger, owner of Beach Road Chicken Dinners

Gloria Bartley, longtime employee of Beach Road Chicken Dinners

Philip W. Miller

Seth Bramson, Florida East Coast Railway Historian

Doris Mellion

Dorothy K. Fletcher

Staci Cobb and Theatre Jacksonville

Stephen J. Smith, photographer

Virginia Fields

Dale Harris

William Sundmacker

Gary Roberts of Robert's Southbank Pharmacy

William Parker

Charlie Patton of the *Florida Times-Union*

All non-credited photographs are part of the author's personal collection.

INTRODUCTION

San Marco sits poised on the river's edge as she has for decades, evolving, growing, and ever changing; a silent witness to everything from jungle movie productions to wartime naval training. San Marco has moved through time from periods of moss-draped plantations and patchworks of platted subdivisions to arrive where she is today: a trendy, highly desired location in Jacksonville, with her Venice-inspired centerpiece: San Marco Square. San Marco Square attracts tourists and locals alike, who stroll down wide brick sidewalks, pausing to window-shop, browse in the various boutiques, or enjoy one of the many fine restaurants that ring the square. Activity in the area is punctuated with everything from business suits to biker shorts, Cadillacs to clunkers, high schoolers on lunch break to native-born retirees who would never consider living anywhere else.

San Marco is a place where people still wave to each other from front porches, where neighbors take care of neighbors, and where new residents know the name of every dog on the block, even if they do not always recall the name of the owner. It is a place where luminarias light the way at Christmas, where bands play beside a Gothic church in the spring, and where smiling residents push strollers along shaded sidewalks year-round. San Marco is a walkable American dream community. Yet, behind the picturesque facade is a surprise: a secret history filled with stories as colorful and fascinating as any found in a blockbuster movie. Little known sagas lurk just beneath the feet of San Marco's residents and tourists; tales buried beneath ever-growing layers of asphalt, behind stuccoed walls, and in dense overgrowth along abandoned railroad tracks.

San Marco began as the dream of real estate developer Telfair Stockton, who, inspired by a visit to Venice, designed his latest project around an Italian theme. Over the years, the original 80-acre platted tract of San Marco gradually expanded, the boundaries blurring, seeping into the neighboring communities of St. Nicholas (to the east), San Jose (to the south), and encompassing the ever-changing Southbank (to the north).

The history of the scenic, storybook area that became San Marco goes back to the time of Spanish land grants and sprawling plantations. Most written accounts trace San Marco's early history to William Jones, who received a land grant of 216 acres in 1793 for acreage on the south side of the Cow Ford. It was an acquisition that did not last. The Spanish government regranted it to Williams Hendricks—a name familiar to everyone who travels through San Marco via Hendricks Avenue—and Jones faded into the pages of history books. It was William Hendricks's son Isaac who moved into the area and began cultivating the land and building houses. Later Isaac's second wife, Elizabeth, platted a section of the land west of Kings Road and called it Oklahoma, a name that can still be seen on old plats and deeds. South of Oklahoma was another large plantation: Villa Alexandria, owned by Alexander and Martha Reed Mitchell as their winter home. One small vestige of that plantation remains today: the artesian well located at the intersection of River Road and Elder Lane.

South of the Hendricks Plantation was a large tract owned by Albert Gallatin Philips. He married Isaac Hendricks's daughter Margaret, and they raised their family at Red Bank Plantation. The

house that A. G. Philips built is still standing today on Greenridge Road, and bits of the old Philips community that developed following the Civil War still survive along Old St. Augustine Road.

The Civil War marked the end the plantation era and the beginning of residential subdivisions. Harrison Reed, brother of Mrs. Alexander Mitchell and governor of Florida in 1868, purchased the eastern half of the Hendricks Plantation in the 1870s and platted it, calling it "South Jacksonville." By the 20th century, the entire area was known as South Jacksonville. Located at what was then the edge of civilization, it was effectively separated from its larger cousin on the north bank by the expanse of the St. Johns River. Until 1890, when Henry Flagler built the first bridge in Jacksonville to span the St. Johns River for his railroad, South Jacksonville was accessible only by ferryboat. A bridge for automobiles did not appear until the St. Johns River Bridge (The Acosta) opened on July 1, 1921; and it was not until 1932 when South Jacksonville was officially annexed into the metropolis of Jacksonville. Thus, because its isolation ended slowly over decades, South Jacksonville grew up as an independent community and was incorporated as such in 1907. It had its own fire station, bank, department stores, city hall, and railroad depot. At one time it even had its own airport: the South Jacksonville Air Terminal, which opened on May 25, 1930. It also had, for a brief time, an early version of Disney World called Dixieland Park. Advertised as "The Coney Island of the South," it provided entertainment for both tourists and locals. Several silent movie companies filmed pictures there, often using exotic animals and jungle settings. Dixieland Park's short-lived but spectacular run opened the real possibility that Florida could become a major tourist destination.

By 1910, Atlantic Boulevard was completed from South Jacksonville to the beaches, thus increasing the city's importance as a transportation hub. Several rail lines intersected in South Jacksonville, which further fueled the area's economic growth. Some large industries in the area included: the E.O. Painter Fertilizer Company, the Gibbs Gas Engine Company, and the Florida East Coast Terminal Yard. Yet many South Jacksonville residents still worked across the river and commuted by ferry.

During World War I, the Merrill-Stevens Shipyard, located east of South Jacksonville, became engaged in critical wartime shipbuilding, and in 1919 the Fletcher Park residential development was created to provide housing for the workers. Many of those prairie-style homes were designed by architect Henry Klutho and still exist today.

In the fall of 1925, the completion of the Dixie Highway from Michigan to Miami routed automobiles over the St. Johns River Bridge, down Forest Avenue (now San Marco Boulevard) to Pine Street (now Lasalle Street), and over to Hendricks Avenue. From there the route led down San Jose Boulevard to Old St. Augustine Road and southward to Miami. Telfair Stockton proposed a different flow of traffic: bring cars from Forest Avenue to Hendricks Avenue more directly by extending the road through the new San Marco Square area. He thus created the path motorists follow today. The population continued to increase, and by 1930 South Jacksonville had over 5,000 residents and more paved streets than any other city of its size in Florida.

In the 1940s, aerial photographs show a thriving small city, with multiple railroad lines running along the eastern side and a riverfront teeming with life, including several large industrial complexes and a critical wartime operation: a U.S. Naval Training Station located at the northern terminus of Hendricks Avenue.

By mid-century, life changed again with the coming of the Main Street Bridge, proposed in 1935 with a request for funding from President Roosevelt's public works program. The major thrust of this proposal was a plan for an airport in South Jacksonville designed to serve both land and water aircraft and located between "Mareno Drive and the St. Johns River Bridge." According to the *Jacksonville Journal*, the Jacksonville Chamber of Commerce had no trouble selling the idea of this airport that would include two 4,000-foot runways. Mayor John T. Alsop urged approval for the airport, but today he is remembered instead for the bridge that was actually funded and built and carries his name. The airport plan faded into history. Many Jacksonville residents do not know the "blue bridge's" official name is the John T. Alsop Bridge, and it is usually referred to as the Main Street Bridge. It opened to great fanfare in 1941.

World War II and the years that followed brought big changes to the San Marco/South Jacksonville area. The vicinity, now called the Southbank, transformed from an industrial and military center to a business and tourist-oriented area with the building of the Lobster House Restaurant (1944), The Southside Generating Station (1950), the Aetna (Prudential) Building (1955), and Baptist Memorial Hospital (1955). During this period, the vast numbers of railroad lines that originally fueled the area's growth slowly evaporated and the ferry service, already limping along, all but disappeared. Instead the automobile reigned supreme, and 1958 saw the opening of the expressway system.

The 1960s witnessed the building of the Hilton Hotel (1963), Friendship Fountain (1965), and the Gulf-Life Building (1967). Friendship Fountain was the world's largest for its time, shooting water as high as 120 feet. The decade ended with the completion of the modern building for the Jacksonville Children's Museum in 1969.

The 1970s ushered in what could only be called a period of decline for San Marco. Many businesses in the square closed their doors, and by the end of the decade only a few stalwarts remained open. Some of those included: Pic 'N Save, Peterson's, Herman Jackson Cleaners, and White's. The original residents of San Marco were aging, and many houses became rentals or were left vacant as their owners died or moved away. The picturesque South Jacksonville Railway Depot, once a thriving center of the community, sat abandoned and deteriorated. The decision was made to tear it down. Today most residents of San Marco are unaware that it ever existed.

Yet San Marco never slipped too far and was not down for long. Only 10 years later, she began to rise again. The San Marco Preservation Society was established in 1975 and helped provide the catalyst needed to resurrect the area. New residents moved in and fell in love with San Marco as a previous generation had. Young singles and families purchased the vacant homes, spending many hours patching, painting, and planting—restoring tired properties to their original appearance and charm.

In 2001, the Better Jacksonville Plan was approved by voters and helped sustain the continued resurgence of San Marco. Roadways were landscaped, pocket parks created, and San Marco entered the new century resplendent and optimistic. So it is today. What changes may evolve in the future remain to be seen, but San Marco is beautiful while she waits.

One

EARLY DAYS
PLANTATIONS AND PIONEERS

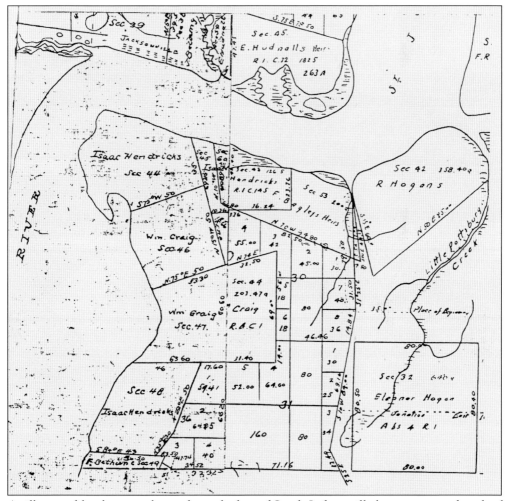

As illustrated by the map above, the early days of South Jacksonville began as a patchwork of variously sized land grants. Today's platted subdivisions were all carved out of these original pieces of land, many of which have names familiar to San Marco residents today, like Hendricks, Hogan, and Craig. (Courtesy of Phillip W. Miller.)

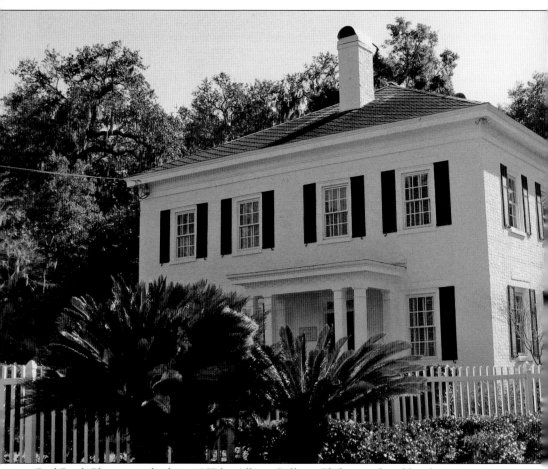

Red Bank Plantation, built in 1857 by Albert Gallatin Philips, is the oldest known structure in San Marco. It is still standing today, located on Greenridge Road. The land on which Red Bank Plantation was established was part of a Spanish land grant given to Albert's father, sea captain Matthew Henry Philips. Matthew Philips had little interest in living on his granted acreage, since it was then a wilderness plagued by Native Americans and alligators. Thus the land passed through several other owners before Captain Philips's son, A. G. Phillips, bought it and built a log cabin on the property. He lived there for several years before beginning work on the home that survives today. That house took two years to complete and was constructed with bricks molded from a clay pit on the plantation. After the Civil War, when the plantation became difficult to run, large portions of the property were sold and platted into the subdivisions that remain today.

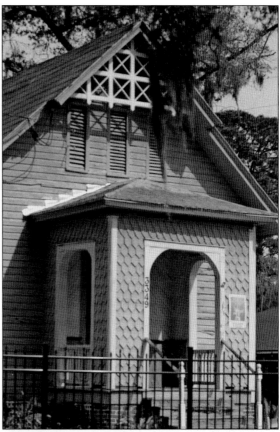

During the mid-1800s, the small town of Philips developed along Old Kings Road (now St. Augustine Road). The town was named after Albert Gallatin Philips, owner of Red Bank Plantation. Some of the residents of Philips were former slaves from Red Bank Plantation and other plantations who sought to build a new life following emancipation. In 1881, the Halifax River Railroad was built, and it ran through the town of Philips. Pictured here is the Old Philips Congregational Church, built in 1887 in the frame vernacular style. (Note the two different patterns of shingles on the porch.) It is one of the few surviving structures of the Philips community. (Courtesy of Stephen J. Smith.)

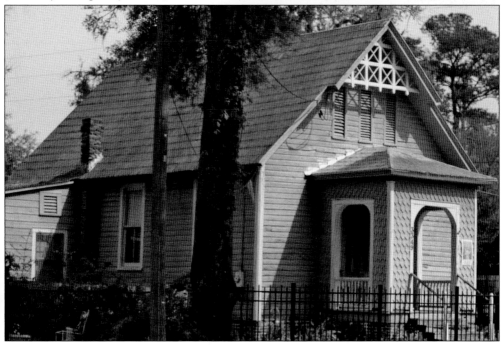

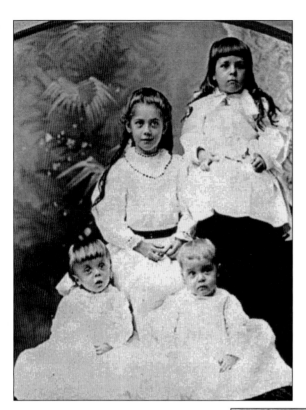

The Philips children are seen here in an undated photograph. Pictured from left to right are (first row) Harold T. Philips and Henry B. Philips; (second row) Charlotte Hendricks Philips and Matthew P. Philips. These children were most likely all born and raised at Red Bank Plantation. (Courtesy of the State Archives of Florida.)

Duval County judge Henry Bethune Philips is the gentleman for whom Philips Highway was named in 1934. He was also the first chairman of the State Road Board, the forerunner of the Florida Department of Transportation. Today some highway markers and street signs spell Philips correctly with a single "L," but others still use the incorrect double "L." (Courtesy of the State Archives of Florida.)

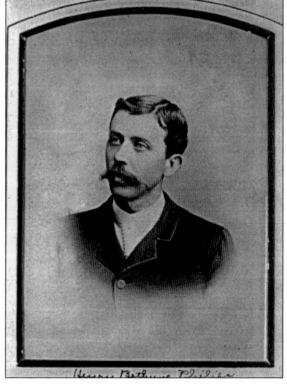

Another early San Marco plantation belonged to a woman named Martha Reed Mitchell (1817–1902). She is seen in the right photograph sitting beneath a large oak tree with an unidentified man. Martha Mitchell came to Jacksonville in 1867 with her husband, wealthy railroad tycoon Alexander Mitchell. At the time, South Jacksonville was called Oklahoma, a name that can still be found on old plats and deeds. Martha Mitchell fell in love with the area and persuaded her husband to buy a 140-acre tract of land on the St. Johns River. Here she built a large winter estate called Villa Alexandria. Sparing no expense, she hired expert builders, had huge dimensional lumber shipped in on schooners, and installed sewers even before the house was built. At that time there were no sewers anywhere south of Charleston, South Carolina. (Courtesy of the State Archives of Florida.)

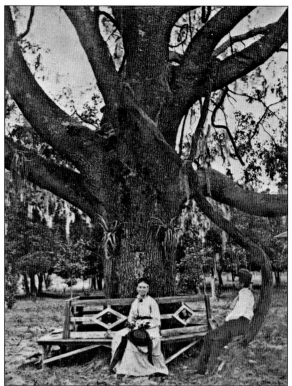

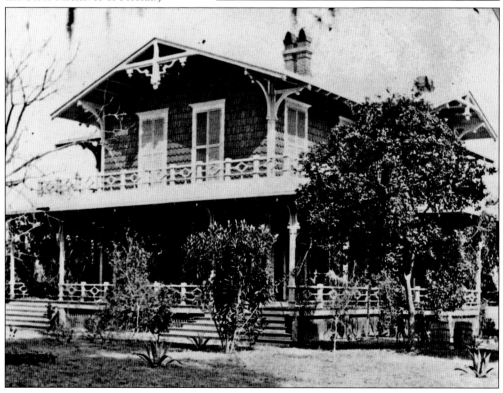

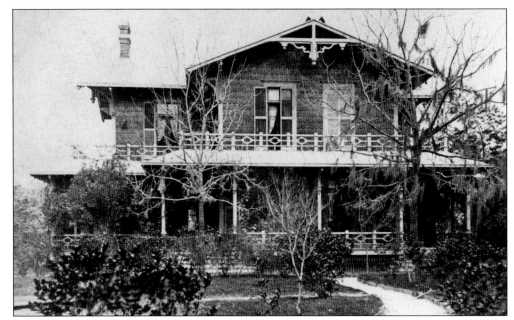

The Villa Alexandria homestead was a relatively modest two-story frame dwelling, described by Harriett Beecher Stowe as an "Italian Swiss Villa." The home's beautifully appointed interior featured items acquired from Martha Mitchell's world travels and included expensive draperies, furniture, and paintings. Each year she hosted a lawn party to benefit St. Luke's Hospital, one of her many philanthropic causes. (Courtesy of the State Archives of Florida.)

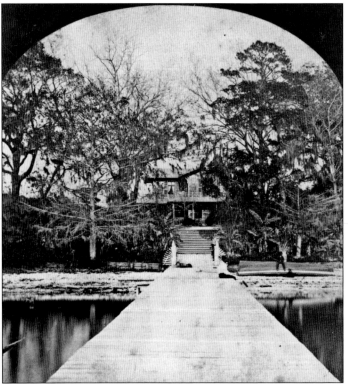

A party at the Villa Alexandria was the social event of the season, with boats hired to carry guests across the river. They would disembark on the landing above, their footsteps echoing across the dock. Upon arrival, a 25¢ admission fee would be collected to benefit one of Martha Mitchell's charitable causes. At the time there was no electricity, so the grounds were lit by hundreds of Japanese lanterns. (Courtesy of the State Archives of Florida.)

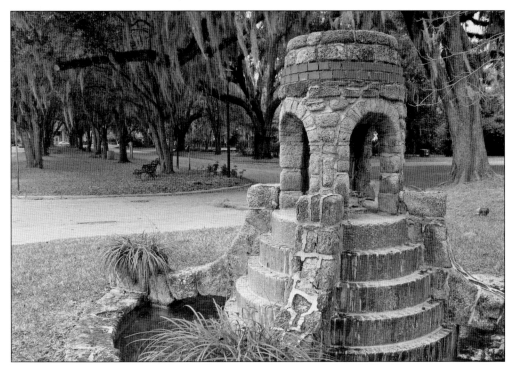

The artesian well that once refreshed horses traveling to and from Villa Alexandria can still be seen today, bubbling merrily near the intersection of River Road and Elder Lane. San Marco residents often stroll down this avenue of trees that mark the route of the former carriage lane of the estate.

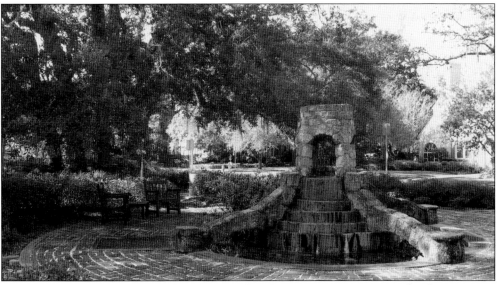

This is not the same artesian well as seen in the previous picture. Nor was this fountain part of the original Villa Alexandria estate. Instead, this structure was built when the San Marco development was created. It was designed to mimic the artesian well from the carriage lane of Villa Alexandria. This twin cousin graces the center of the park located between Largo Place and Largo Road.

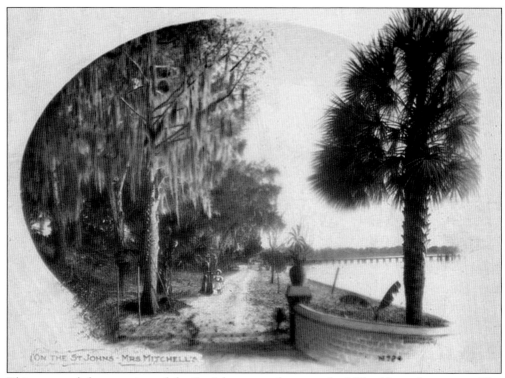

This postcard shows a view of the St. Johns waterfront on the Villa Alexandria estate. The exact vantage point of this photograph is unknown, but the curved brick wall and southern view suggest a northwestern property entrance. Note the pineapple sculpture, a well-known symbol of hospitality. (Courtesy of the State Archives of Florida.)

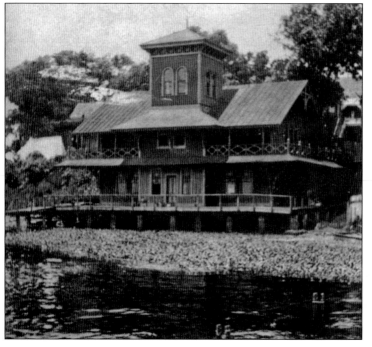

This photograph at left, taken in 1908, shows the former Villa Alexandria boathouse. As the estate fell into disrepair, the boathouse was barged across the river to a site near the current Florida Times-Union building. The structure was used to house the Jacksonville Power Boat Club until it was torn down in 1960. (Courtesy of the State Archives of Florida.)

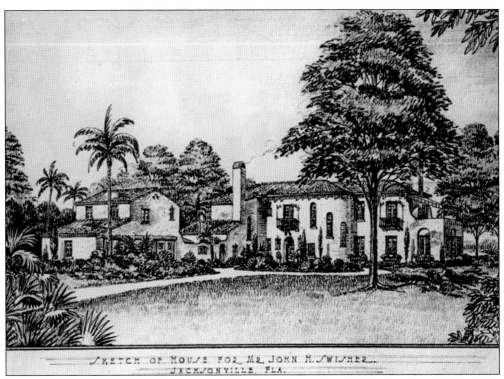

SKETCH OF HOUSE FOR MR. JOHN H. SWISHER.
JACKSONVILLE FLA.

By 1925, Villa Alexandria had been vacant for many years and was badly deteriorated. The Villa Alexandria Company was formed to prevent further problems and vandalism, and all the remaining buildings were razed. In 1927, the property was turned over to the Telfair Stockton Company, who subdivided it into a series of waterfront lots. The first lot sold went to John Swisher of the King Edward Cigar Company, and later, in 1930, his brother Carl purchased the adjoining lot and built a similar Spanish-style estate on what was formerly the tennis court area of Villa Alexandria. The photograph below shows the entrance gate of the Swisher property more than 50 years later. Both homes still exist near the intersection of River Road and Arbor Lane. (Above, courtesy of the State of Florida Photographic Archives.)

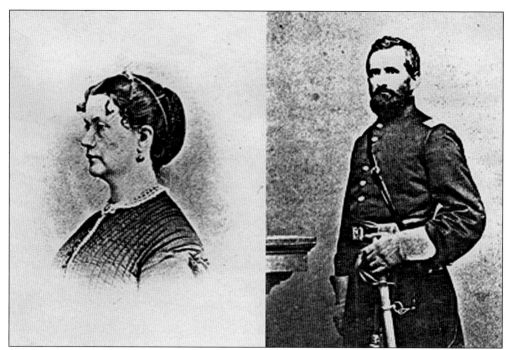

Harriet R. C. Stevens came to Florida from Minnesota in 1879. She and her husband, George (pictured in his Civil War uniform), bought land east of South Jacksonville on Big Pottsburg Creek, "near where the Great Oaks stand." The area was a wilderness with no churches nearby, so Harriet Stevens began holding small Sunday school services in her home. Soon other religious services were added. Below is the only known photograph of the Stevens's original homestead. In this modest house, the fledgling St. Paul's Episcopal Church was born. By 1887, the church had grown to the point that Harriet Stevens realized a dedicated church building would be required. (Courtesy of St. Paul's Episcopal Church.)

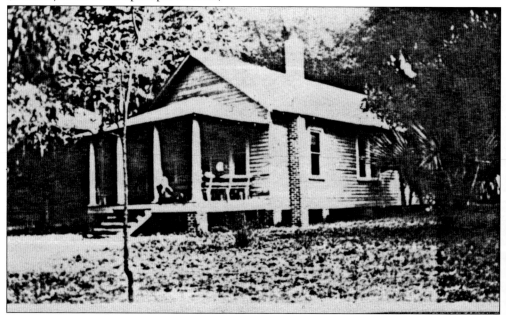

Harriet Stevens enlisted the financial aid of her friends in Minnesota, and in 1888 the St. Paul's Episcopal Church building was erected on the corner of Atlantic Boulevard and Bartram Road. At this time, Atlantic Boulevard was little more than a sandy, unpaved wagon trail. One account in the church history states that the Reverend Albion W. Knight (later Bishop Knight), of St. Andrew's, drew up the plans for St. Paul's and held the first services there. The church building was constructed by D. H. Murnahan, a carpenter who came to the area from Michigan in 1887. His hopes of bringing his family to Florida with the money he earned from building the church were not realized. He died in the yellow fever epidemic that swept the area in 1888, not long after he completed the picturesque Carpenter Gothic structure. (Courtesy of St. Paul's Episcopal Church.)

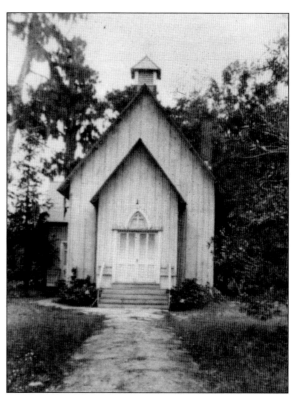

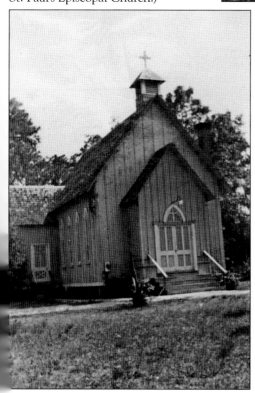

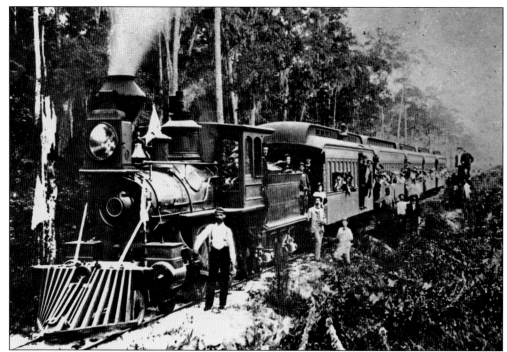

The 36-mile-long, narrow-gauge rail line (above) of the Jacksonville, St. Augustine, and Halifax River Railway connected Jacksonville to St. Augustine. The company was incorporated on February 21, 1881. The organization purchased wharf property on the south bank of the St. Johns River in South Jacksonville along with a ferryboat, the *Armsmear*. The rail line's extension to St. Augustine was completed in 1885 but never made it to its intended destination, the Halifax River in Daytona. Ten years later on September 13, 1895, the Jacksonville, St. Augustine, and Halifax River Railway merged with the Jacksonville, St. Augustine, and Indian River Railroad and was renamed the Florida East Coast Railway. (Courtesy of the State Archives of Florida.)

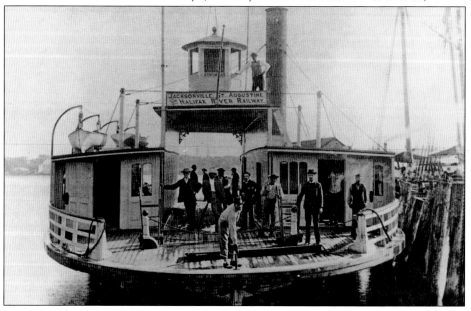

As late as 1876, there were no major rail lines south of Jacksonville, but that changed when Henry Flagler built a railroad bridge across the St. Johns River. The bridge is pictured here in an early stage of construction. Note the partially completed capped pile piers visible in the river. On January 5, 1890, the first train crossed the bridge as spectators watched from the wharves. (Courtesy of the State Archives of Florida.)

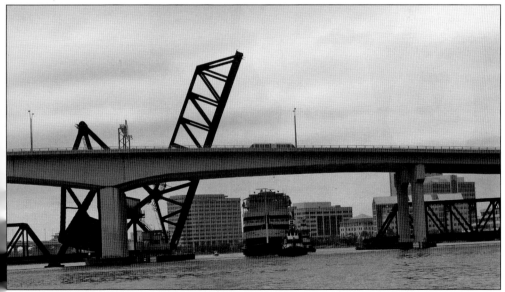

This photograph depicts a meeting of the eras. The old railroad bridge, angled in the up position, is silhouetted against a low skyline of modern buildings. Just visible zipping across the new Acosta Bridge is the People Mover. Representations of life in three different centuries come together here in a poignant tableau.

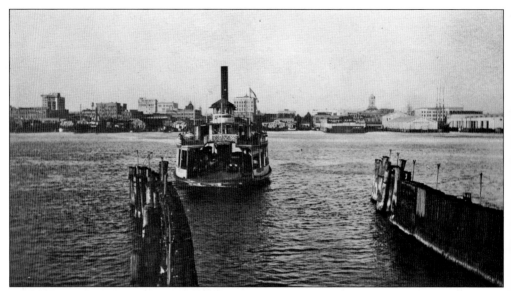

This 1917 photograph of a ferry approaching the South Jacksonville dock was taken only a few years before the St. Johns River Bridge (the Acosta Bridge) was built. The coming of that bridge marked the beginning of rapid development in the area that was to become known as San Marco. (Courtesy of the State Archives of Florida.)

Gradually, platted homesites began to replace large plantations. It was Harrison Reed, brother of Martha Reed Mitchell, who bought a portion of the Hendricks grant and platted it as South Jacksonville. The remainder of the grant was platted in 1882 by Elizabeth Hendricks and named Oklahoma. This is a view of the St. Johns River from a platted site that was once part of Villa Alexandria.

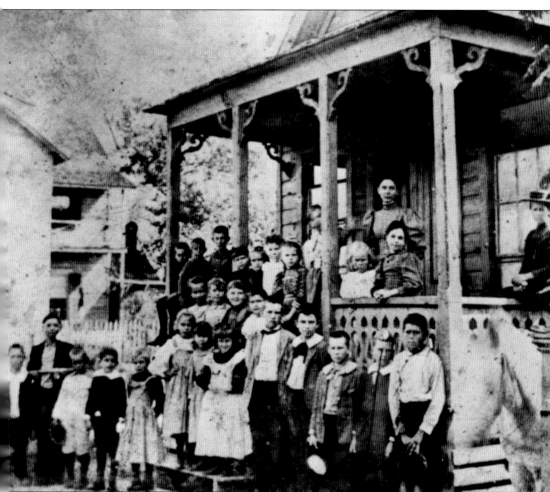

Julia Landon, seen here standing on the porch behind her students, was a teacher at the first one-room grammar school in South Jacksonville around 1910. Landon Middle School, which carries her name, is located on land that was homesteaded by her parents (John and Mary Landon) after the Civil War. John and Mary Landon moved to the area from Ohio in 1865, purchased 8 acres of land and built a log cabin. Later they added a 10-room house, which housed three generations of the family. According to a handwritten notation in a 1960s Landon yearbook, the woman wearing the hat and sitting on the porch banister is M. Clauzelle Whaley. She was still teaching mathematics at Landon High School in 1965. John and Mary Landon are buried in the Craig Swamp Cemetery (Philips Cemetery) located on St. Augustine Road near the Old Philips Congregational Church. (Courtesy of the State Archives of Florida.)

The area called Oklahoma was incorporated into the city of South Jacksonville in 1907. It included the Hendricks grant and the northern portion of the Craig grant. In that same year Mary Landon subdivided her property and named the new development "Shadyside." However, the area was not an immediate success, and almost two decades elapsed before all of the lots were purchased and houses constructed. These two sections from a 1923 plat map show a portion of the new development, complete with the shaded footprint of "Mrs. Landon's house," located on the eastern side of Minerva Avenue. Myrtle Avenue is now called Thacker Avenue, and Julia Avenue is Arcadia Place. Julia and Minerva were Mary Landon's daughters. Landon Middle School, formerly Landon Junior and Senior High School, is located between Minerva Avenue and Thacker Avenue near the site of the former Landon family home. (Courtesy of the City of Jacksonville.)

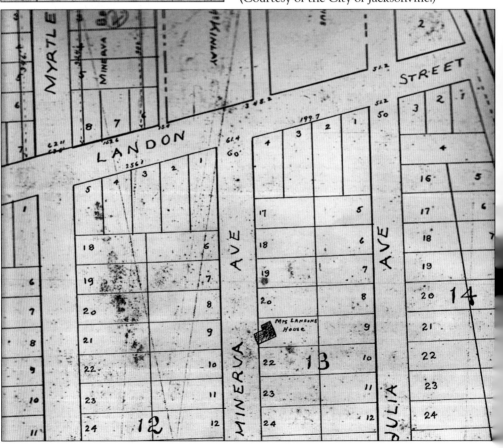

Seen here is F. W. Bruce, the builder of the Merrill-Stevens shipbuilding plant in South Jacksonville and former chief engineer of the Port Commission for Jacksonville. The Merrill-Stevens Shipyard was located east of South Jacksonville. During wartime, it was engaged in critical shipbuilding operations for the U.S. military. In 1919, the development of Fletcher Park was platted, and homes were built to house workers of the facility. (Courtesy of the State Archives of Florida.)

Many of the original Fletcher Park houses still exist. The two pictured above are on Landon Avenue and illustrate two of the four basic designs that were built. The development was named for Sen. Duncan U. Fletcher, and construction began in July 1918. By April 1919, all of the 158 houses had been completed. The architects of the project included Henry Klutho, Earl Mark, Leeroy Sheftall, and Mellen Greeley. (Courtesy of Stephen J. Smith.)

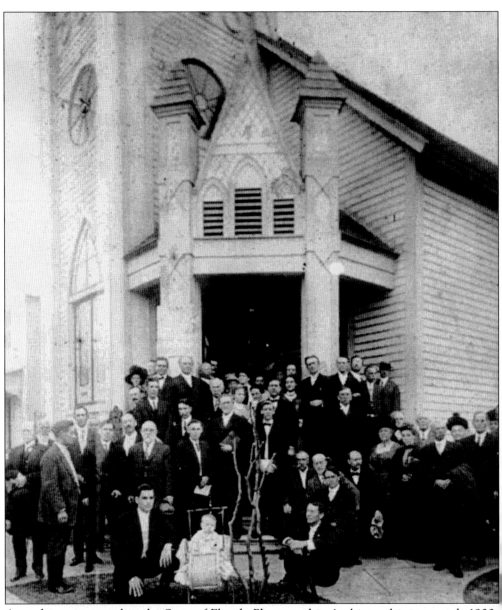

According to a record in the State of Florida Photographic Archives, this is an early-1900s photograph of the congregation of the Elizabeth Swaim Memorial United Methodist Church. The parishioners appear to be standing on the steps of the Grace Methodist Episcopal Church (which later became the Elizabeth Swaim Memorial United Methodist Church), located on Myrtle Avenue (now Kings Avenue). It was one of the first congregations founded in South Jacksonville. This picture was probably taken soon after the church building was completed in 1893, when the structure still had its ornate corner porch and before the entryway was relocated to the front of the building. Before the Grace M. E. Church was built, South Jacksonville church members either took a ferry across the St. Johns River to attend services at Trinity Church (now the Snyder Memorial Church) in downtown Jacksonville, or held services in nearby members' homes. (Courtesy of the State Archives of Florida.)

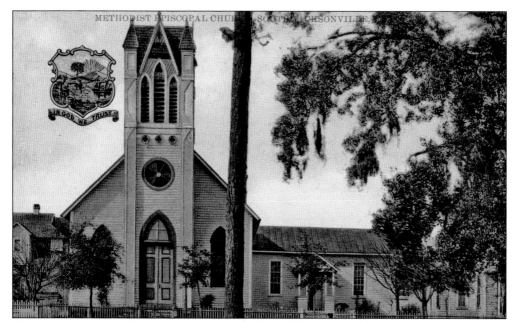

This is a postcard rendering of the Grace Methodist Episcopal Church, the forerunner of the Elizabeth Swaim Memorial United Methodist Church. It was located near the northern end of Myrtle Avenue, a short distance from the St. Johns River. Today that area is part of Kings Avenue. Compare the photograph of the Swaim congregation on the previous page to this postcard. (Courtesy of the Jacksonville Public Library.)

The Elizabeth Swaim Memorial United Methodist Church and parsonage, pictured here on LaSalle Street in the 1920s, traces its beginning to September 27, 1886. On that day, an organizational meeting was held in the home of Gov. Harrison Reed, and out of that meeting the Grace Methodist Episcopal Church was born. A property trade in 1922 resulted in the acquisition of the land on which the church now stands. (Courtesy of the State Archives of Florida.)

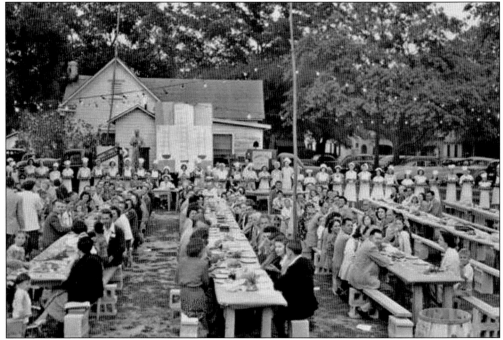

This is a photograph of a church supper at the Elizabeth Swaim Memorial United Methodist Church in the 1940s. Capt. Wilber Welling Swaim, an original church trustee, suggested the church's name. He named it for his wife, Elizabeth Caroline Booth Swaim, who was the first Sunday school teacher at the church. It was officially renamed the Elizabeth Swaim Memorial United Methodist Church during the church's dedication on December 13, 1925. (Courtesy of the State Archives of Florida.)

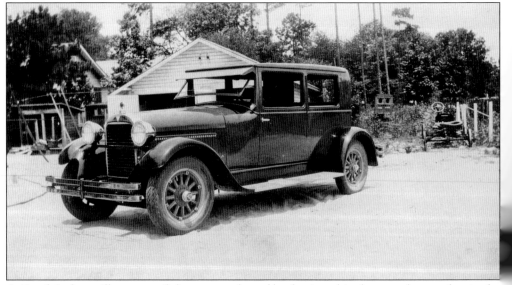

As South Jacksonville grew, trails became roads, and by the time this photograph was taken in the 1920s, automobiles began to populate the landscape. The opening of the St. Johns River Bridge accelerated the development of the area, and Lasalle Street, where this car is parked, became one of the major routes through the community. (Courtesy of J. L. White.)

Two

DECADES BEFORE DISNEY
DREAMS IN SOUTH JACKSONVILLE

Dixieland Park was billed as "Jacksonville's Greatest Resort" and "Florida's Playground." It had "everything to amuse," including a skating rink, a swimming pool called "The Plunge" that was used for aquatic concerts, and—appropriately—a Dixieland band directed by Louis Grunthal. Customers could dine at Bentley's Restaurant, witness Fannie Gregory perform in her flying automobile, and then attend a play at the Dixie Theater. (Courtesy of the Jacksonville Historical Society.)

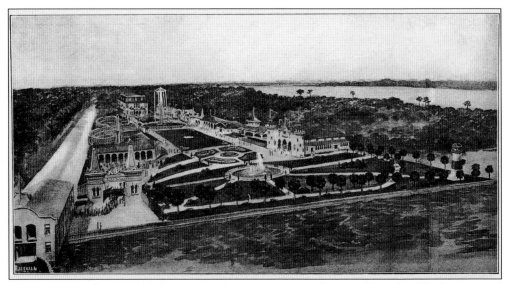

This rare image from a 1907 German publication shows the layout of Dixieland Park. It opened to the public on March 9, 1907, and was an immediate sensation. The property encompassed 21 acres, with 1,100 feet of river frontage. Bounded on the east by Flagler Avenue, it extended almost to Miami Road (Prudential Drive). Billing itself as "The Coney Island of the South," it attracted tourists and locals alike. (Courtesy of Jacksonville Public Library.)

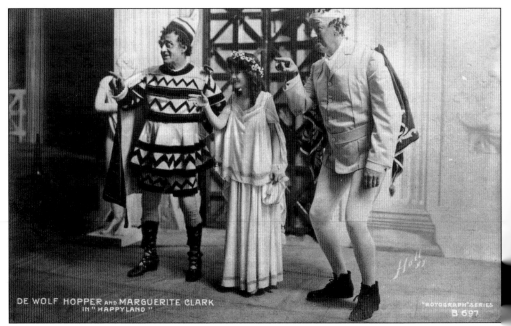

Dixie Theater opened to great fanfare with its first offering: the play *Happyland*, starring famous actors of the day: De Wolf Hopper and Marguerite Clarke. They are seen above in a real-photo postcard costumed for the same play. The gentleman on the right is unidentified. An original company that was put together by Schubert in New York did *Happyland*.

Dixieland Park included a 160-foot roller coaster, a "laughing gallery," a "House of Troubles," a toboggan ride, hot air balloon rides and a large merry-go-round called "The Flying Jenny." The property also included a large theater building. In 1908, a baseball park was added on the eastern side of the park. It was used for spring training by many major league teams. (Courtesy Jacksonville Public Library.)

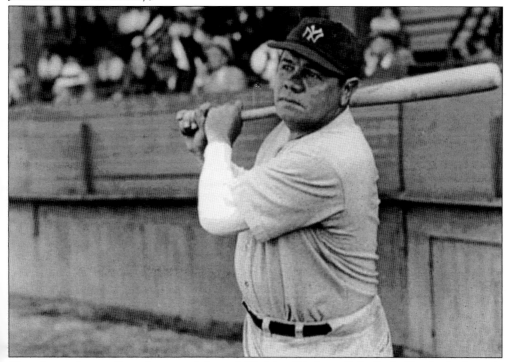

One of many famous faces that passed through Dixieland Park was Babe Ruth. Hundreds of people came to see him play an exhibition game at the attraction's baseball park. This photograph, taken in Jacksonville, was snapped sometime after Babe Ruth was sold to the New York Yankees for $125,000 in 1920. (Courtesy of the State of Florida Archives.)

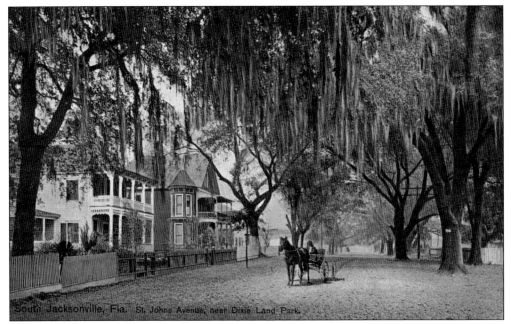

This early postcard shows a picturesque, moss-draped St. Johns Avenue (today's Prudential Drive), near "Dixie Land Park." A 1913 Sanborn map states that St. Johns Avenue was "brick paved from Ames Avenue (now Flagler) to Myrtle Avenue (now part of Kings Road). The same source also states: "Public lights electric." (Courtesy of Jacksonville Public Library.)

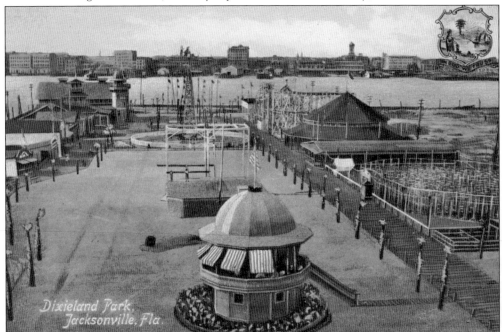

This is a northward-looking view that shows how Dixieland Park appeared in 1908. The Jacksonville city skyline is visible in the distance, across the expanse of the St. Johns River. On the far right of the picture is the area of the property that contained the ostrich farm. To capture this picture, the photographer may have been standing on the steps of the Dixie Theater.

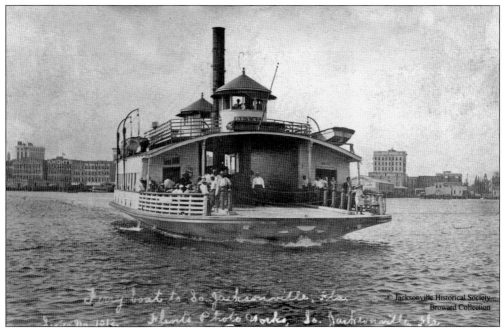

One advertisement for Dixieland Park proclaimed: "Two High-class Ferry Boats ply between Dixieland and the City—a Boat leaving each side every seven and one-half minutes." The ferryboat *Duval*, pictured here, was one of those who carried visitors to the park. The caption written on the bottom reads, in part: "Ferry Boat to So. Jacksonville, Fla." (Courtesy of Jacksonville Historical Society.)

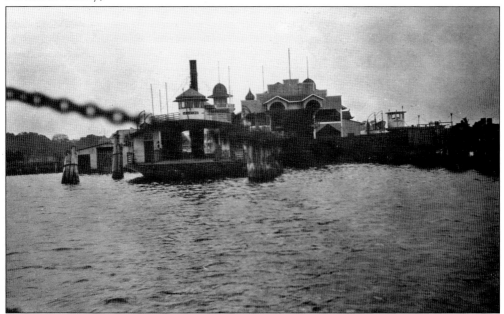

The ferryboat *Duval* is seen here at the dock of Dixieland Park patiently awaiting its next run. The spires and ornate peaks of some of the park's buildings are clearly visible in the background. The chain running across the foreground of the picture suggests that the photographer was standing on the deck of another ferry. (Courtesy of the State of Florida Archives.)

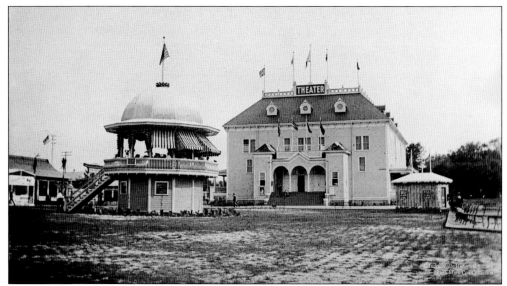

The Dixie Theater was built at a cost of $30,000 and was described as "one of the finest" theaters in the south. It had a seating capacity of 1,200 "without one undesirable seat in the house." When it was built, the theater was one of the largest frame structures in the city. Its life as a theater was short-lived, however. The last theatrical group to perform there was the Ruth Raynor Company in 1909. The building still existed in 1954, the last survivor of Dixieland Park. A 1913 Sanborn map lists it as "formerly Dixie Theater," and in 1949 it is a "Furniture Store." The Dixie Theater was located on the south side of Mary Street near Flagler Avenue. The photograph below shows the building at a later date when it was called the Park Theater Studios. (Above, courtesy of Jacksonville Historical Society; below, courtesy of the State of Florida Archives.)

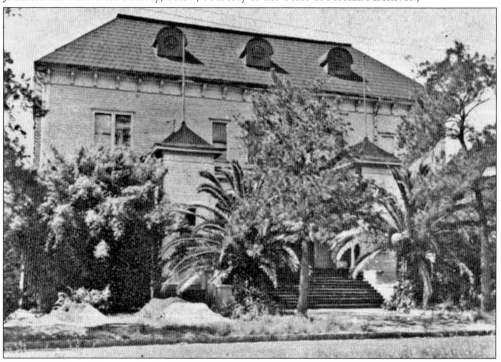

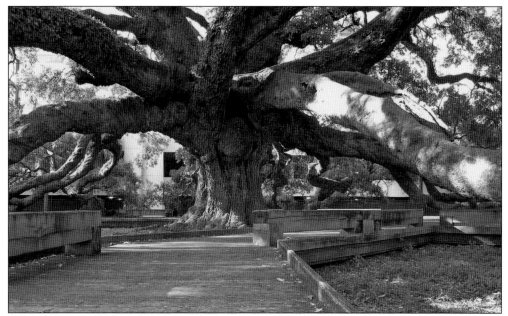

Dixieland Park began a slow, gradual decline beginning just a year after she opened. This was partially due to losses by several fires, but even so, vestiges of the park hung on until 1916. Many silent movie companies rented space at Dixieland, but none stayed for long. The Florida Ostrich and Alligator Farm carried on into the 1920s, but eventually it all succumbed to competition from other, more easily accessible, northern Jacksonville venues. Yet, one lone survivor of Dixieland Park remains: the Treaty Oak, seen above. Today this massive tree is the centerpiece of the charming Jessie Ball DuPont Park. When Dixieland Park finally faded forever into history, it left this legacy: it paved the way for future Florida theme parks like Disney World. (Above, courtesy of Junius; below, courtesy of the Jacksonville Public Library.)

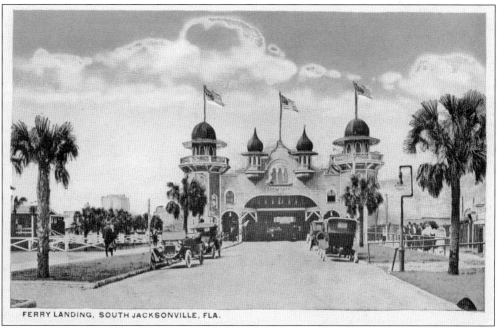

FERRY LANDING, SOUTH JACKSONVILLE, FLA.

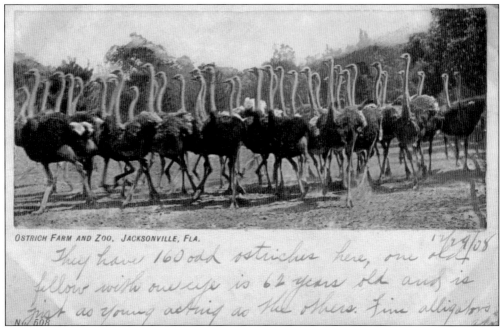

OSTRICH FARM AND ZOO, JACKSONVILLE, FLA.

They have 160 odd ostriches here, one old fellow with one eye is 62 years old and is just as young acting as the others. Fine alligators

The attraction was called the Florida Ostrich and Alligator Farm when it was located at Phoenix Park, near Talleyrand on the north side of the St. Johns River. When it moved to South Jacksonville the name changed to the Florida Ostrich Farm and the Florida Alligator Farm. The postcard below shows a group of baby ostriches. The caption on the back of this card, dated February 8, 1908, reads: "We visited ostrich farm and Mid-winter Exposition today. Having a fine time." The successful Mid-Winter Exposition mentioned was held a short distance away from Dixieland Park. A 32-foot viaduct was built across Flagler Avenue to connect the event to the park. The following year, the less-successful Florida Exposition Fair of 1909 was held at the South Jacksonville baseball park. The highlight of its two-month run was a staged train wreck.

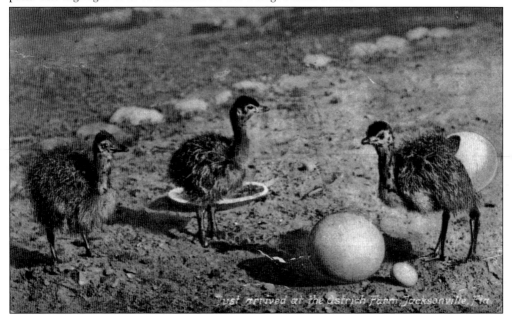

Just arrived at the Ostrich Farm, Jacksonville, Fla.

The Florida Ostrich and Alligator Farms occupied over 30 riverfront acres at the South Jacksonville ferry landing (now the foot of the Main Street Bridge), including the site where the Prudential Building now stands. The Florida Ostrich Farm initially charged a 10¢ admission, and, as mentioned in the advertisement at right, its souvenir shops offered a variety of related objects, like ostrich feathers, eggs, fluffy boas, and "fancies." (Courtesy Jacksonville Public Library.)

OSTRICH AND ALLIGATOR FARM

The Florida Ostrich Farm

SOUTH JACKSONVILLE, FLA.

The largest ostrich farm in the East. All ages and sizes, from "chicks" just hatched. Nubian ostriches, and fancy birds from all parts, etc., etc. Riding and driving ostriches daily at 11:30 a. m. and 3:30 p. m. A complete line of Ostrich Feathers, Plumes, Tips, Hat Fancies, etc., etc.

JUST ACROSS THE BRIDGE OR FERRY

The Florida Alligator Farm

(Young Alligator Joe's place)

SOUTH JACKSONVILLE, FLA.

The largest alligator farm in the world, exhibiting the largest alligators in captivity, to small babies just hatched; crocodiles, snakes, turtles, and many other curiosities. Exhibitions daily with trained alligators "shooting the chutes," catching and hypnotizing wild 'gators, etc., at 11 a. m. and 3 p. m. Alligator leather goods of all kind.

JUST ACROSS THE BRIDGE OR FERRY

JACKSONVILLE CITY DIRECTORY (1926)

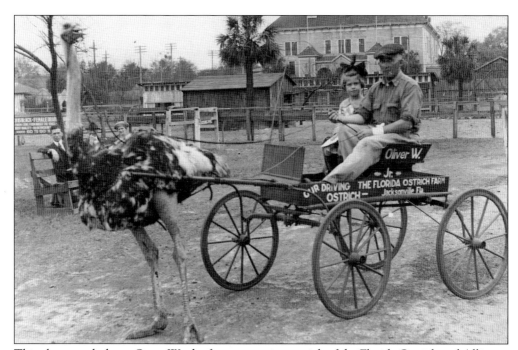

This photograph shows Oscar W., the famous trotting ostrich of the Florida Ostrich and Alligator Farm. Oscar W. is pulling a cart carrying two unidentified riders, and spectators relaxing on a park bench observe them. The scene is clearly on the grounds of Dixieland Park. The Dixie Theater building is the prominent structure in the background. (Courtesy Jacksonville Public Library.)

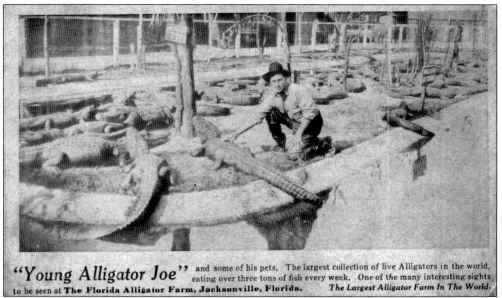

"*Young Alligator Joe*" and some of his pets. The largest collection of live Alligators in the world, eating over three tons of fish every week. One of the many interesting sights to be seen at **The Florida Alligator Farm, Jacksonville, Florida.** *The Largest Alligator Farm In The World.*

Alligator Joe, whose real name was Hubert Ian Campbell, worked in Buffalo Bill's Wild West Show until he met his wife, Sadie. She worked with him until his death in 1926, doing everything from capturing alligators and snakes, to managing the gift shop. They lived in a houseboat near the ferry dock and could frequently be seen walking their pet otter on a leash.

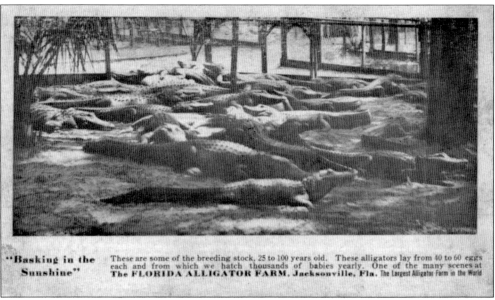

"**Basking in the Sunshine**" These are some of the breeding stock, 25 to 100 years old. These alligators lay from 40 to 60 eggs each and from which we hatch thousands of babies yearly. One of the many scenes at **The FLORIDA ALLIGATOR FARM, Jacksonville, Fla.** The Largest Alligator Farm in the World

Alligator Joe was the originator of alligator farming in America. Despite his flair as an entertainer, he was a respected naturalist who merged his alligator farm with the ostrich farm in an effort to help preserve and study both species. He is buried in Evergreen Cemetery, and his headstone reads: "Hubert Ian Campbell, born in Berhampur, India, June 10, 1872, Died in Jacksonville Fla., March 10, 1926, Beloved by All."

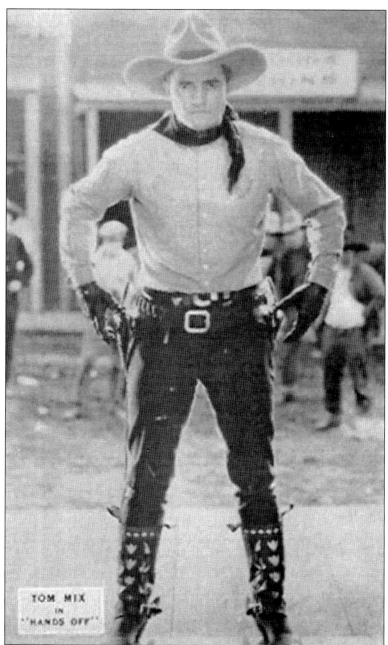

TOM MIX
IN
"HANDS OFF"

Tom Mix, best known for his cowboy movies, filmed some of his earliest work on the grounds of Dixieland Park. William Selig, a pioneer in the movie business, was impressed with Tom's on-screen performances and sent him to Florida to act in a series of jungle movies. Tom Mix began his career doing supporting roles with actress Kathlyn Williams in two films: *Back to the Primitive* (1911) and *Hearts of the Jungle* (1915). One of the many animals used for these pictures was an elephant named Toddles. Toddles was part of the menagerie of jungle animals rented from animal trainer Tom Persons. According to an account written by Tom Persons's wife, Olive, about their time in Dixieland Park, Toddles was an extremely loyal elephant who would listen to no one but Tom and could often be seen following him around the set.

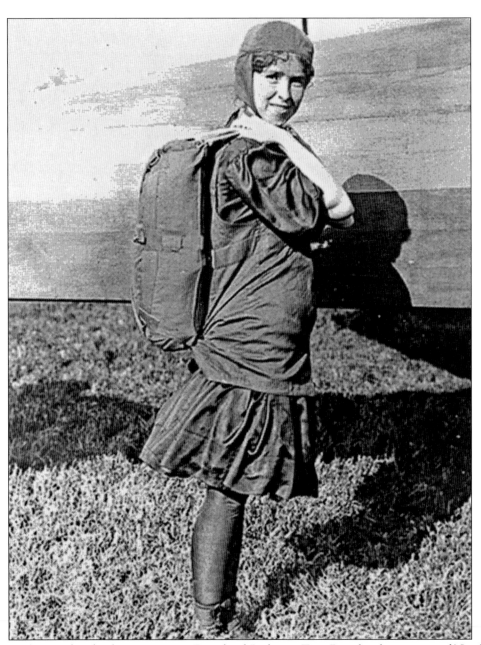

One of many daredevil attractions at Dixieland Park was Tiny Broadwick, a native of North Carolina whose real name was Georgia Ann Thompson. Barely 4 feet tall, she thrilled audiences by parachuting from a hot air balloon. In 1913, she became the first woman to jump from an airplane and later went on to amaze the army's Aviation Bureau when she demonstrated jumping from a plane with a parachute on her back. During World War I, she served as an advisor to the fledgling aeronautics corps. Tiny Broadwick stopped jumping in 1922 after more than 1,100 jumps, giving up her life in entertainment to take an assembly line job in a tire factory. She said she simply could not make enough money in carnivals. The parachute she used in that first history-making jump is now housed at the Smithsonian Institution. (Courtesy of the North Carolina State Archives.)

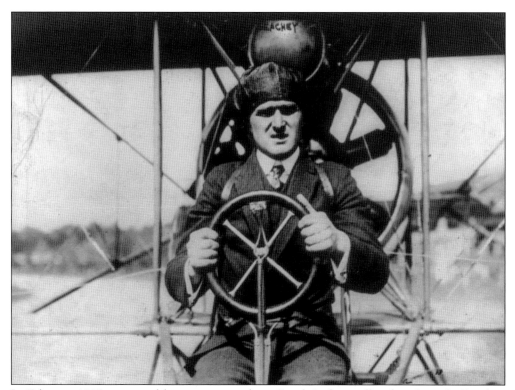

In February 1908, air travel history was made in South Jacksonville when Lincoln Beachey made the first flight in a motor-propelled airship. Beachey, who always dressed in a suit for his appearances, was in the air for 12 minutes piloting a dirigible known as the *Beachey Airship No. 6.* One news account said he landed as "easily as the merest of birds drops to the swinging topmost bough of some favored tree." (Courtesy of the Library of Congress.)

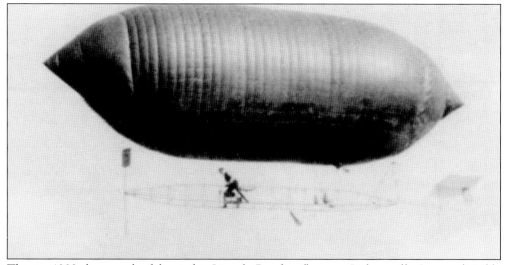

This is a 1908 photograph of the airship Lincoln Beachey flew over Jacksonville. It was a dirigible equipped with a rudder behind and a propeller in front. It had a 4-cylinder, 10-horsepower gasoline engine that weighed 82 pounds. The total weight of the airship was 240 pounds. Beachey arrived in Jacksonville with this slogan: "Hark, the herald angels sing; Beachey's ship is just the thing."

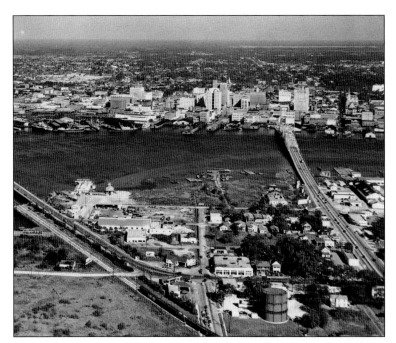

An aerial view of the south bank of the St. Johns River in the 1940s shows the Main Street and Acosta bridges and between them a portion of the area that once housed Dixieland Park and the Florida Ostrich and Alligator Farm. The round structure in the foreground is listed on a 1949 Sanborn map as a "gas holder."

This 1920s photograph shows an unidentified girl and her beloved dog. Exactly where they are sitting is unclear. The location may be Flagler Avenue, possibly between LaSalle and Cedar Streets. If so, none of the houses in the background are still in existence. In the 1920s, Flagler Avenue extended all the way to the river, running near the area that was once part of Dixieland Park. (Courtesy J. L. White.)

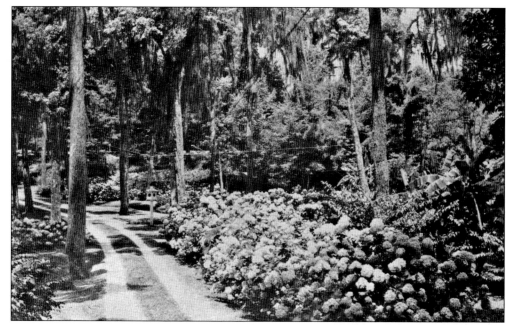

In 1925, Riverside resident George W. Clark began planting the overflow from his botanical garden on a vacant piece of land overlooking the St. Johns River. Soon, these 18 acres would be opened to the public as Oriental Gardens. From 1937 until it closed in 1954, the gardens were one of Jacksonville's premiere attractions, charming tourists and residents alike.

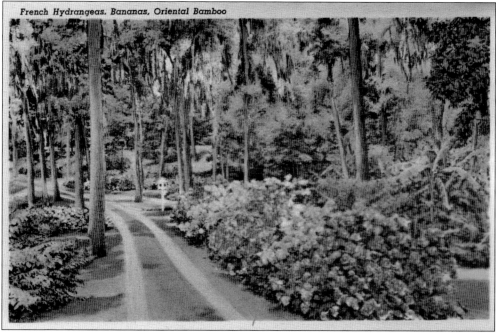

French Hydrangeas, Bananas, Oriental Bamboo

This postcard features the same scene as the above photograph. The card was produced in full color, to portray the splendor of the gardens that included hydrangeas, banana trees, bamboo, and several varieties of oaks and palm trees. Postcards of Oriental Gardens were manufactured in abundance and sold in the gift shop on the premises.

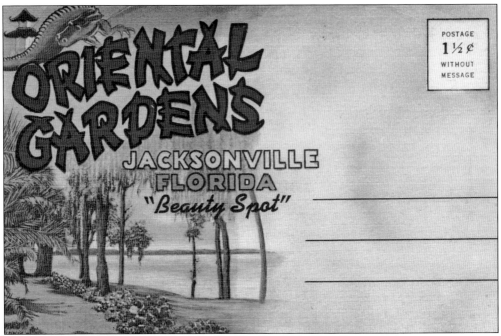

Oriental Gardens offered visitors more than a variety of plants, bridges, fountains, scenic vistas, and sunken pools. "The Singing Gardens of Jacksonville" also presented hourly concerts of their famous chimes, advertised as sounding "better in a garden than anywhere else on earth." Although a recording that was piped outside by hidden speakers probably produced the music, the effect undoubtedly added to the ambiance of the setting.

Oriental Gardens was a favorite destination for local residents as well as out-of-town visitors. This photograph from the 1939 Landon High School yearbook indicates how often the area was used as a photographic backdrop for a variety of occasions—from high school graduation portraits to simple scenic vistas.

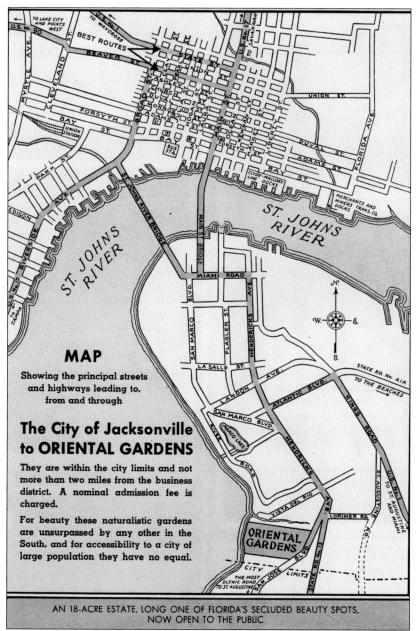

Taken from an early brochure for Oriental Gardens, this map shows the location of the attraction, just north of the Jacksonville city limits line. It also documents the evolution of street names in the San Marco area. Miami Road was originally called St. Johns Avenue and is now Prudential Drive. This map shows the more colloquial "Main St. Bridge," despite the official name being the John T. Alsop Bridge. Today the city limits are many miles further south. Note that San Jose Boulevard is called "the most scenic road to St. Augustine." From 1937 until 1954, Oriental Gardens was one of Jacksonville's major attractions, but in 1954 State Investment Company purchased the property and divided it into 33 single-family homesites. Today observant San Marco residents who walk, drive, or ride bicycles down Oriental Gardens Drive can still spot a few remnants of the once splendid tourist attraction.

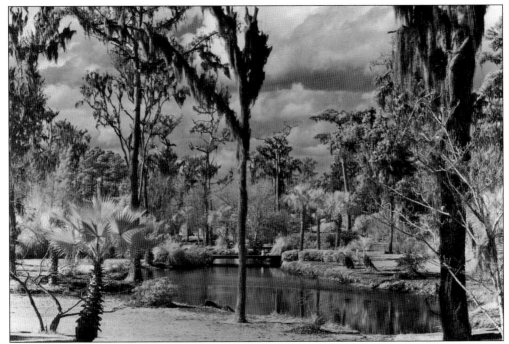

Probably dating from the late 1940s, this photograph shows Craig Creek as it curves though River Oaks Park. The park is located just north of the Oriental Gardens property and south of the various cul de sac streets that extend off River Oaks Road. The creek was named for William Craig, one of South Jacksonville's early settlers. Prior to being drained in the 1920s, the area was swampy and filled with alligators and water moccasins. Below is a postcard view, taken from a similar vantage point, that shows Craig Creek with River Oaks Park in full bloom. Today the park looks much the same as it did 50 years ago, although the varieties of flowering plants seen in the postcard view no longer exist.

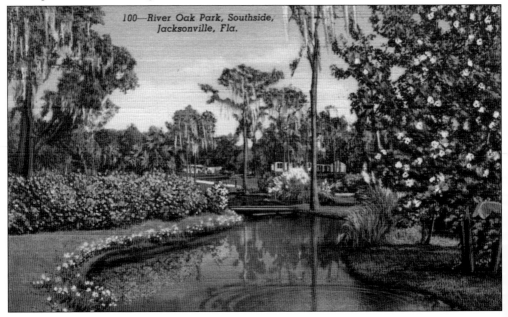

100—River Oak Park, Southside, Jacksonville, Fla.

Further south on San Jose Boulevard is a residential area called Ardsley, developed by great showman and animal trainer Percy J. Mundy. Colonel Mundy performed at the Dixieland Exposition in 1909, intending to stay only a few months. But, lured by the movie studios and encouraged by his wife, he decided to put down roots in South Jacksonville. He purchased a large tract of land on San Jose Boulevard and built a mansion overlooking the river called Hollywood Park. A portion of that tract was later platted as the Ardsley Development, located just south of today's Miramar Shopping area. At right, this portrait of Percy J. Mundy appeared in the *St. John Sun* newspaper in 1906. Percy J. Mundy and his wife, Alice, are buried just down the road from their Hollywood Park home at Oaklawn Cemetery.

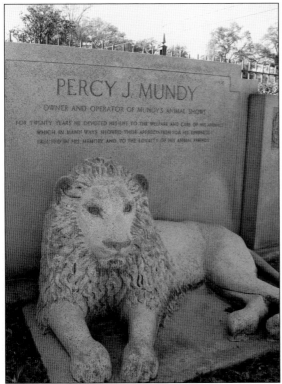

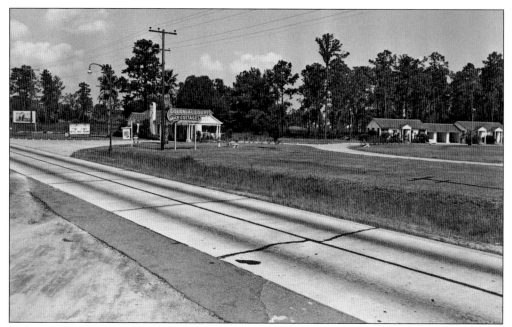

Colonial Hotel Courts, seen here in the 1940s, was one of many similar tourist accommodations that sprang up along Philips Highway (U.S. 1) as Florida became a major vacation destination. This site on the eastern side of the highway is currently occupied by Hugo's Interiors, located about one-half mile north of Emerson Street.

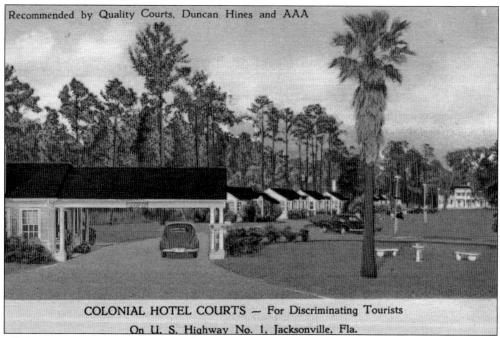

Recommended by Quality Courts, Duncan Hines and AAA

COLONIAL HOTEL COURTS — For Discriminating Tourists

On U. S. Highway No. 1, Jacksonville, Fla.

Above is a postcard of the Colonial Hotel Courts from the 1940s. The caption on the back reads: "Finest from Maine to Miami, on U.S. No. 1, 2 miles South of St. Johns River, Jacksonville, Florida. All tile baths with tub or shower, fully carpeted floors, central steam heat, spacious grounds beautifully landscaped, some air conditioned rooms."

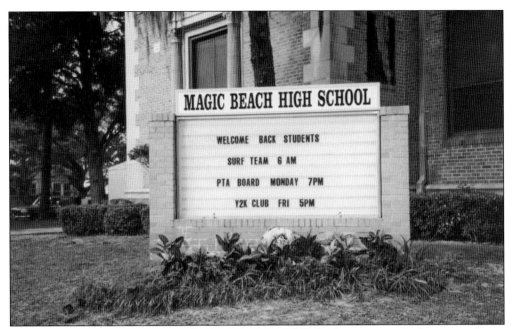

Although different than it was in the days of Dixieland Park, the movie and television industry is still alive and growing in Jacksonville. In 1999, the short-lived television series *Safe Harbor* was filmed here, and Landon Middle School on Thacker Avenue was transformed into Magic Beach High School for the occasion.

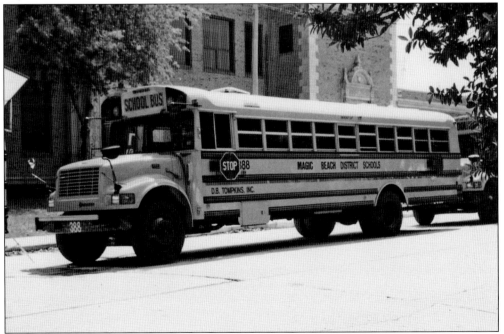

To complete the illusion of the fictitious town of Magic Beach for the television series, Duval County schools buses were pressed into service, masquerading as Magic Beach school buses. They even had appropriate signage slipped onto the side of each vehicle. *Safe Harbor* featured well-known stars Rue McClanahan and Gregory Harrison, but the series lasted only one season.

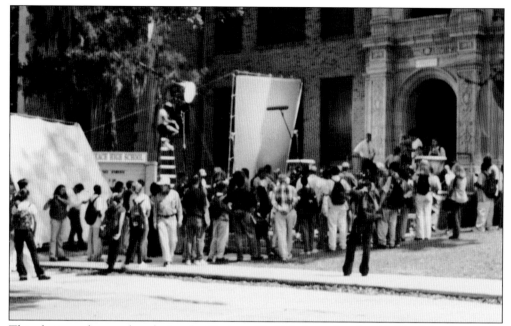

This photograph was taken during the filming of *Safe Harbor* at Landon Middle School, with the northwest entrance archway of the school clearly visible. The picture shows only a portion of the number of people required for producing a single scene. Other films shot in San Marco include the movie *Recount* and the 1994–1995 television series *Pointman*, starring Jack Scalia.

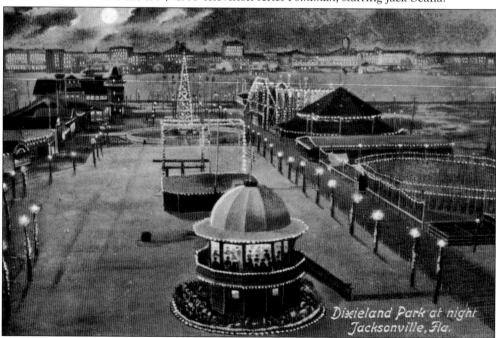

From its rudimentary beginning at places like Dixieland Park, the tourist industry continues to blossom in and around San Marco. The postcard above portrays the same scene as the one on page 34, but this nighttime vista illustrates something that amazed park visitors at the time: a multitude of electric lights.

Three

SOUTH JACKSONVILLE DAYS
PEOPLE AND PLACES

Posing in their roadster parked off LaSalle Street are driver Thomas Patterson II and his girlfriend, Ina. Lorraine Patterson and Genevieve "Sis" Patterson are in the rumble seat. Alma Peek is the child barely visible next to Thomas's head. The Elizabeth Swaim Memorial United Methodist Church can be seen in the background. (Courtesy of J. L. White.)

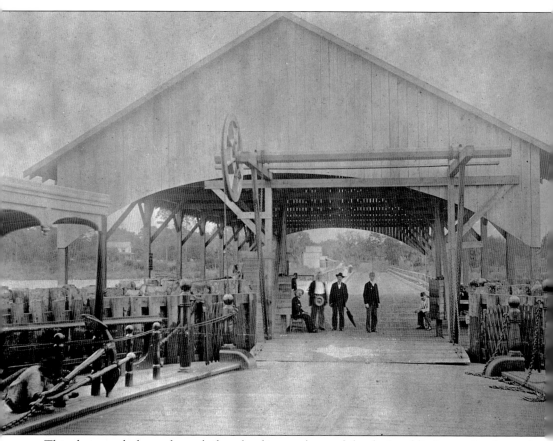

This photograph shows the early ferry landing on the south bank. A public ferry existed as early as 1774, and it operated from the south side of the river. In 1800, the Hendricks family operated a ferry from the south side. Passengers on the north bank who required transportation across the river sometimes resorted to firing a gun to attract the ferryman's attention. It was not until 1818 that John Brady established service from the north side of the river. Ferry service remained a critical link between the north and south banks of the St. Johns River, even after the coming of the St. Johns River Bridge in 1921. Residential development on the south side had its rudimentary beginnings in the mid-1800s, and by the 20th century the small community became generally known as South Jacksonville. It was officially incorporated into a town in 1907. (Courtesy of State of Florida Archives.)

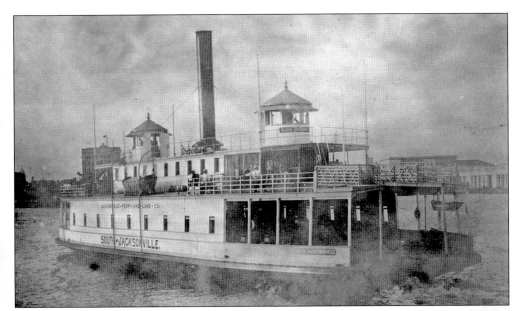

The South Jacksonville ferry was one of a long line of steam ferryboats that ran between Jacksonville and South Jacksonville. On March 15, 1905, the South Jacksonville Steam Ferry Company was granted a franchise from the county commissioners that fostered extensive improvements, including bulkheading the riverfront. During the process of building the bulkhead, the remains of previous ferries were covered up since most old ferries were simply dumped along the river when they were damaged beyond repair or retired from service. After serving her time in Jacksonville, on April 2, 1922, the *South Jacksonville* bid the city farewell with a single toot of her whistle and departed for her new job ferrying passengers in Philadelphia. Pictured at right is South Jacksonville ferry captain William Henry Carlton standing with young James W. Hadley. (Courtesy of State of Florida Archives.)

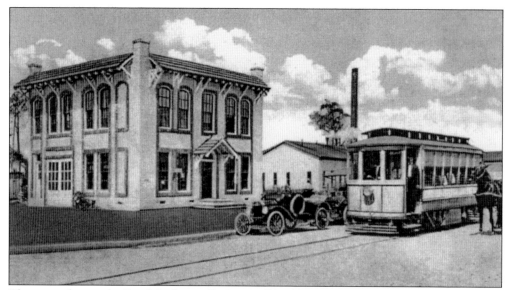

This scene depicts the South Jacksonville City Hall building on the corner of Hendricks Avenue and Cedar Street. It clearly shows the trolley line that ran down Hendricks Avenue. The city hall building was restored to its original appearance in 2008, spearheaded by the San Marco Preservation Society. From 1915 until 1932, this two-story brick building served as the center of government for South Jacksonville. (Courtesy of Jacksonville Public Library.)

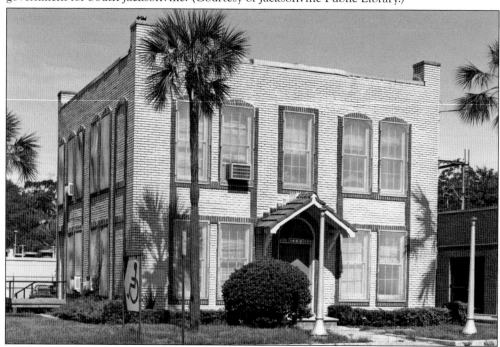

This is a 1985 photograph of the South Jacksonville City Hall building. Constructed in 1915, it is one of the oldest remaining buildings in the San Marco area. The 2008 renovation of the building restored its original exterior appearance by replacing the tile roof missing in this photograph. This small, two story brick structure is a reminder of the days when South Jacksonville was a city separate and unique from Jacksonville. (Courtesy of Judy Davis)

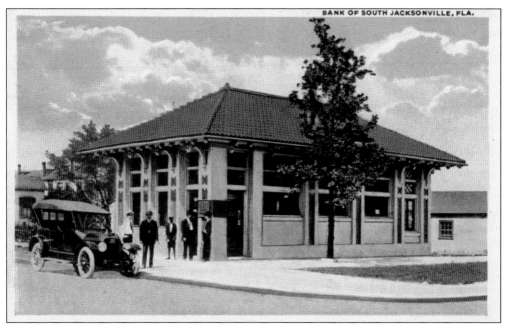

The Bank of South Jacksonville was organized on July 18, 1912, and located on the northwest corner of Hendricks Avenue and St. Johns Avenue (now Prudential Drive). It opened for business on July 24, 1912, with $25,000 in capital. On July 27, 1921, the bank was robbed of $3,800 during a daring daylight robbery. The five robbers, despite being unmasked, managed to make a clean getaway and were never apprehended. (Courtesy of Jacksonville Public Library.)

This advertisement for the Bank of South Jacksonville is from the Jacksonville City Directory of 1925. Safety must have indeed been "paramount" to the bank in the wake of the 1921 robbery. This was only the second year South Jacksonville had its own section in the city directory and was referred to as "The Brooklyn of Greater Jacksonville." Courtesy of the Jacksonville Public Library.)

BANKS

H. B. PHILIPS, Pres.
L. A. USINA, 1st V.-Pres.
R. O. MOORE, Vice-Pres.

G. D. BARNETT, Cashier
A. F. PIET, Asst. Cashier
JULIAN C. REYNOLDS, Asst. Cashier

Bank of
South Jacksonville

ESTABLISHED 1912

Where Safety Is Paramount

STATE, COUNTY AND
CITY DEPOSITORY

ST. JOHNS AND HENDRICKS AVES., S. J.
PHONES 5565 and 4510

The South Jacksonville Waterworks building is seen here with the railroad tracks near Hendricks Avenue visible in the foreground. Until the 1960s, this structure housed the public water utility. It pumped water from the underground aquifer into clarifiers and through aerators before the water entered the supply lines. Until it was torn down, the tall water tower on the property could be seen from almost any location in San Marco.

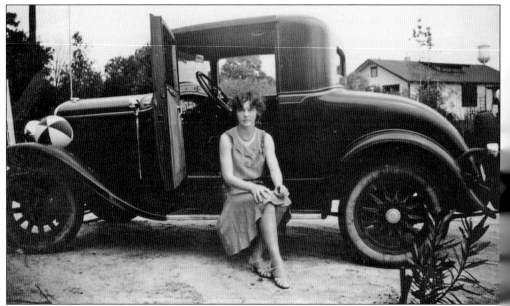

In this late 1920s photograph, Lorraine Patterson is seen sitting on the running board of her automobile. The beach ball on the fender may provide a clue about her intended destination. In the far right corner of the picture, the water tower located on the property of the South Jacksonville Waterworks is clearly visible. (Courtesy of J. L. White.)

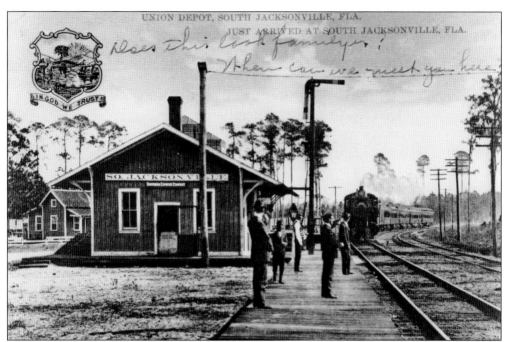

This is a 1920s postcard view of the Union Depot in South Jacksonville, looking eastward toward an approaching train. The depot was east of the intersection of Hendricks Avenue and Cedar Street on the north side of the tracks. It was called Union Depot at this time because several rail lines intersected at this location. Like other Florida East Coast Railway buildings, the depot and all the related structures were painted yellow. (Courtesy of the Collection of Seth H. Bramson, FEC Railway Company historian.)

This photograph of the South Jacksonville Depot was taken after the western end had been remodeled. Compare this photograph with the one above. The doorway has been moved to the left and one window eliminated. Judging by the truck in the foreground, this picture was taken in the late 1950s or early 1960s. Just visible in the distance is the Crabtree Lumber Company. (Photograph by Thomas Biddy; courtesy of the Collection of Seth H. Bramson, FEC Railway Company historian.)

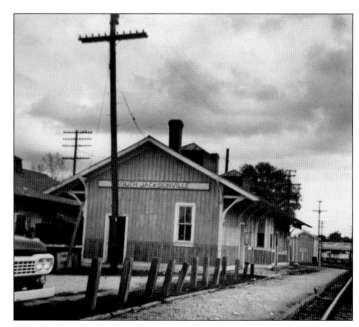

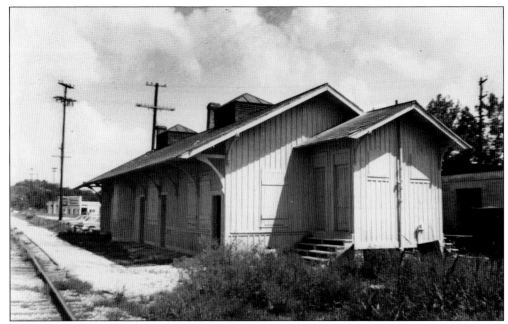

This photograph was taken on July 1, 1968, and it depicts the shuttered South Jacksonville Depot not long after it was closed forever. The billboard in the distance features an advertisement for the popular restaurant Beach Road Chicken Dinners (see page 88). The depot was torn down in the 1970s, and no trace of it remains. (Courtesy of the Collection of Seth H. Bramson, FEC Railway Company historian.)

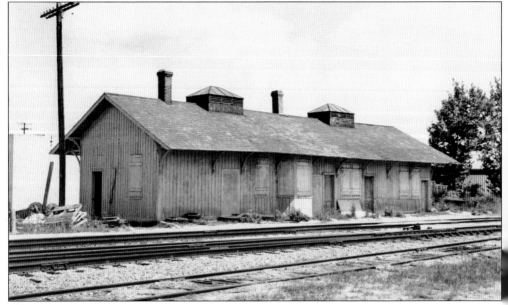

This is probably one of the last photographs ever taken of the South Jacksonville Depot. It was snapped on September 17, 1970, and clearly shows a tired and neglected structure. Today this site is vacant, located just across the tracks from the popular Southside Tennis Courts. Nothing remains to bear witness to the once bustling station and the events that occurred there. (Courtesy of the Collection of Seth H. Bramson, FEC Railway Company historian.)

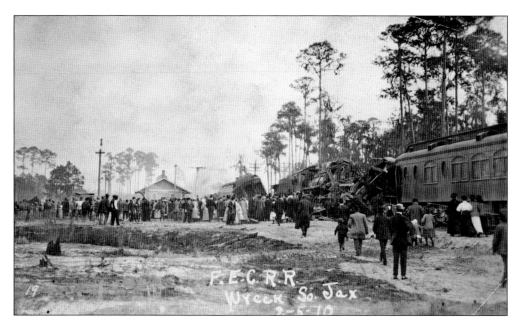

On February 6, 1910, a fatal train wreck occurred at the South Jacksonville Depot that was sensational enough to be reported in many newspapers, including the *New York Times*. Local flagman J. L. Baker had just hopped on the train from the nearby water tower when the train was struck by the Over Sea Limited. Five coaches were destroyed, the roof of a Pullman car was lifted off and thrown through the air a distance of 40 feet, and J. L. Baker was killed. The Over Sea Limited train was headed to New York from Knights Key and was traveling at 40 miles per hour when it impacted the rear end of the New Smyrna Express, which was stopped at the South Jacksonville Depot. Conductor L. D. Edwards, flagman Oscar Ostrander, Arthur Cole, and passenger Mrs. J. M. Schumacker were seriously injured. (Above, courtesy of State of Florida Archives; below, courtesy of the Jacksonville Historical Society.)

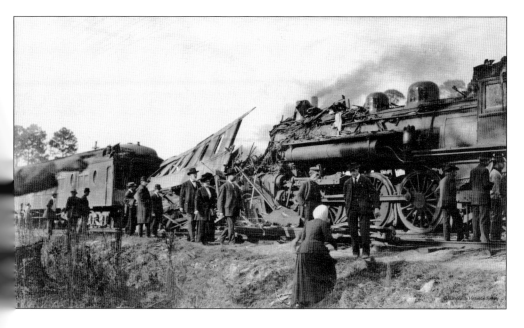

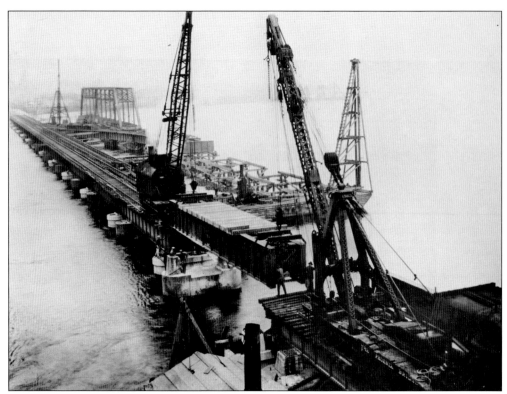

Using ferries to transport his passengers and railroad cars across the river quickly proved unsatisfactory. In 1890, Henry Flagler built the first bridge in Jacksonville to span the St. Johns River, a double track railroad bridge. On January 5 of that year, the first train crossed the bridge, an event celebrated more in St. Augustine than in Jacksonville. (Courtesy of State of Florida Archives.)

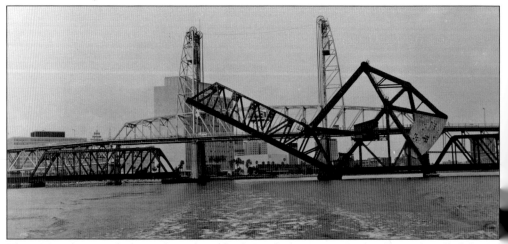

This 1960s photograph shows the railroad bridge with the Acosta Bridge (formerly called the St. Johns River Bridge) in the background. Voters approved construction of the automobile bridge on July 10, 1917, and the first shovel of dirt was thrown on September 25, 1919, by St. Elmo W. Acosta. The bridge opened to traffic on July 1, 1921, and was advertised as "Duval County's Gift to Florida." (Courtesy of State of Florida Archives.)

Lorraine Patterson is seen here standing just off LaSalle Street in 1930. The small church in the background is on Flagler Avenue, and the buildings in the distance are on Hendricks Avenue. The license plate on the car reads: "Jacksonville Bridge Permit 1930." Apparently residents of South Jacksonville had tags that allowed them to cross the St. Johns River Bridge without stopping to pay a toll each time. (Courtesy of J. L. White.)

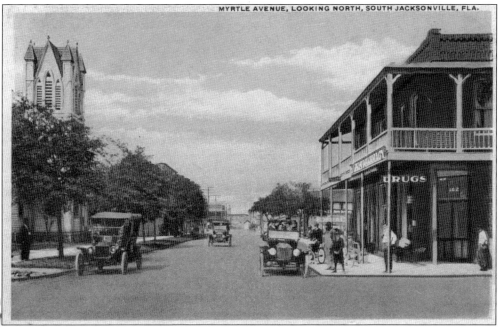

This undated postcard shows the intersection of Myrtle Avenue and Louisa Street. The church steeple visible on the left is the Grace Methodist Episcopal (M. E.) Church. This northern end of Myrtle Avenue later became part of Kings Avenue, and the section of Myrtle Avenue between the South Jacksonville Railroad Depot and Mitchell Avenue was renamed Thacker Avenue.

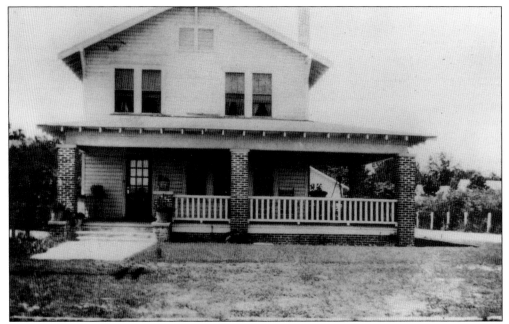

This photograph was taken in 1923, just after the house above was completed. Located on LaSalle Street, it was built by Thomas Edward Patterson. It has been owned consecutively and lived in continuously by the same family up to the present day. LaSalle Street, originally called Pine Street, served as one of the main streets in South Jacksonville. (Courtesy of J. L. White.)

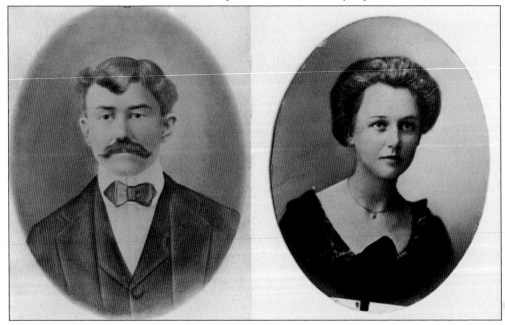

Married in 1902, Thomas Edward Patterson and Genevieve A. Patterson were the first to reside in the house he built on LaSalle Street. Thomas Patterson owned Patterson Lumber Company, which became Crabtree Lumber and Building Supplies in 1952. Bits of faded lettering from the early days of those businesses can still be seen on the sides of one of the remaining buildings located on Landon Avenue. (Courtesy of J. L. White.)

Thomas Patterson is seen here in his later years, standing in the backyard of his home on LaSalle Street. His wife, Genevieve, is standing on the porch. Visible in the distance is one of the apartment buildings that began to spring up along the street and are still standing today. (Courtesy of J. L. White.)

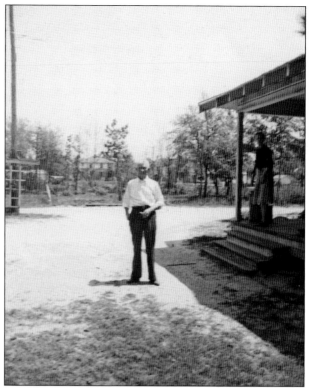

This photograph from 1991 shows Genevieve A. Patterson on her 100th birthday. Standing behind her are her daughters. From left to right are Margaret, Genevieve, Lucille, Alma, and Lorraine. The celebration was held in Mandarin, in the home of Alma's daughter Connie. (Courtesy of J. L. White.)

Dr. Miller's Sanitarium was located on Atlantic Boulevard near White Avenue. It was the first medical center in South Jacksonville. Established in 1914, it was opened by Dr. Samuel D. Miller, M.D. He built it himself and the facility was maintained through a succession of other physicians until it was sold in 1975. The former Nurses Home on the property existed until a fire claimed it in 2009. (Courtesy of State of Florida Archives.)

This photograph was taken in 1949 on LaSalle Street near its intersection with Belmonte Avenue. Showing off her ruffled bonnet is Gail Bayer, standing across the street from Southside Christian Church. The Southside Christian Church was constructed in 1940, and today the church building is home to a Montessori school. (Courtesy of J. L. White.)

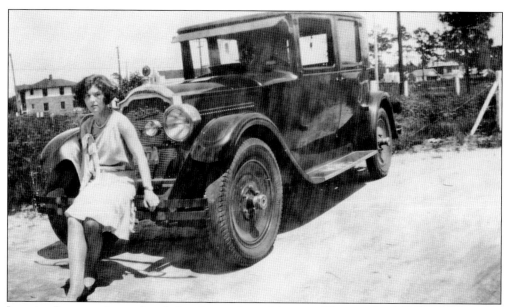

Lorraine Patterson is seen here balancing on the car's bumper. The steeple of the Elizabeth Swaim Memorial United Methodist Church is just visible through the car window, and behind the car is an open pasture. The distant houses (right) are near the present location of Stan's Sandwich Shop, San Marco's restaurant version of Cheers, a friendly place "where everybody knows your name." (Courtesy of J. L. White.)

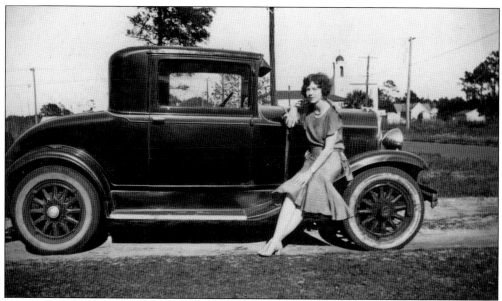

Lorraine Patterson is pictured here with the automobile she always called her "coupé." Clearly visible in the background is the steeple of the Elizabeth Swaim Memorial United Methodist Church. This photograph was taken on the north side of LaSalle Street sometime in the late 1920s and illustrates how undeveloped portions of San Marco were during this period. (Courtesy of J. L. White.)

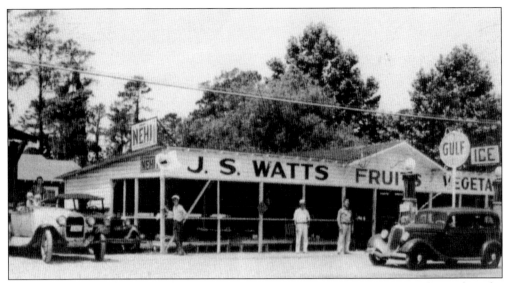

Pictured above is J. S. Watts's fruit and vegetable market and Gulf station. It was located on the south side of Atlantic Boulevard, across the street from the present-day Assumption Catholic Church and Bishop Kenny High School. Today Pulido's Auto Service occupies this land. (Courtesy of Pulido's Auto Service.)

The same location was photographed many decades later. The fruit and vegetable business was replaced by a Krystals restaurant. It was a favorite hangout for local teenagers during the 1950s and even featured carhop service. The building still stands, now a part of Pulido's Auto Service.

Clowning around in their truck are Mr. and Mrs. Charles Forde. Charles is the brother-in-law of Thomas A. Patterson. This photograph was taken in the alleyway between Flagler Avenue and Belmonte Avenue. The house visible in the background was owned by the Quarterman family. It is still standing, now surrounded by many other homes and apartments. (Courtesy of J. S. White.)

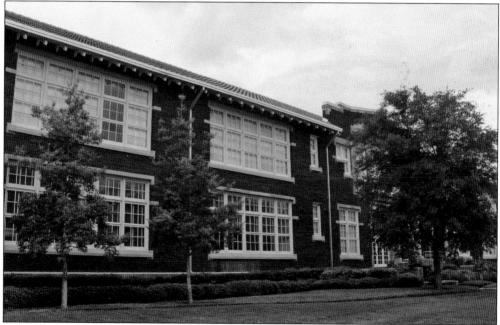

Located at 1450 Flagler Avenue was the South Jacksonville Grammar School, now a condominium complex called the Lofts San Marco. Originally constructed in 1917, it was one of the last prairie-style buildings designed by the architectural firm of Mark and Sheftall. Notice the tile roof evident in this picture. On April 15, 2004, this building was added to the U.S. National Register of Historic Places.

Posing on their front steps are South Jacksonville residents Alma and Margaret Patterson. This photograph was taken in 1929, the year after Landon Junior and Senior High School opened. These girls could now look forward to a future that included attending high school in their own neighborhood. They would thus be spared a twice-daily commute across the river to attend Duval High School in downtown Jacksonville. (Courtesy of J. L. White.)

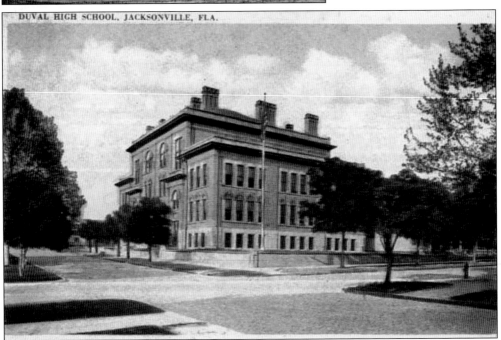

DUVAL HIGH SCHOOL, JACKSONVILLE, FLA.

Until Landon Junior and Senior High School was built in 1927, teenagers who lived in South Jacksonville attended Duval High School, located in downtown Jacksonville. Built in 1907, it was the first public school in Florida to offer coursework beyond the elementary grades. Before the St. Johns River Bridge (the Acosta) was built in 1921, students who lived in South Jacksonville traveled there by ferry. (Courtesy of the Jacksonville Public Library.)

Sporting rolled up sleeves, Herman Greelish is seen here leaning against the fender of his automobile. Standing at his feet, his sleeves also rolled up, is young Alvin Bayer III. This photograph was taken sometime in the 1930s near the alleyway that runs between Flagler Avenue and Belmonte Avenue. (Courtesy of J. L. White.)

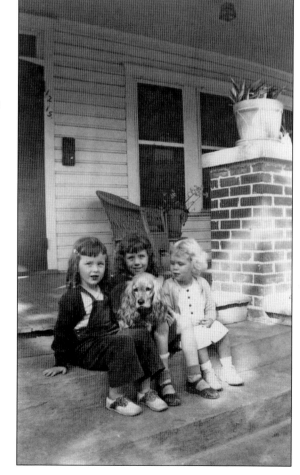

Wicker furniture and potted plants were commonly seen on front porches during the 1940s. Seated on the steps of this home on LaSalle Street are, from left to right, Judy White, an unidentified friend, and Connie Peek. The dog is a red cocker spaniel named Lady Latisha Mamselle. (Courtesy of J. L. White.)

Holding their favorite toys, the children are, from left to right, as follows: Genevieve McDowell, Jean White, Mary McDowell, and Pat McDowell. They are being cared for by Genevieve White. The shadows beside the group are, from left to right, Everette McDowell and Lucille Patterson McDowell. Visible in the distance is the Elizabeth Swaim Memorial United Methodist Church and parsonage. (Courtesy of J. L. White.)

In this 1920s photograph, two unidentified young women pose with lollipops and dolls. Behind them is an advertisement painted on a wall that appears to show a picture of the St. Johns River Bridge and "$15." This may refer to the cost of a bridge permit that residents purchased so they would not have to stop and pay a toll every time they crossed the river. (Courtesy of J. L. White.)

Four

A VISION OF VENICE
SAN MARCO IS BORN

Early automobiles line the street in this 1920s photograph. The scene is River Road during the building of waterfront homes in the new San Marco development. At the time River Road was called Rialto Place. Scaffolding around one house under construction is visible in the distance. Most of these homes are still standing today. (Courtesy of Jacksonville Historical Society.)

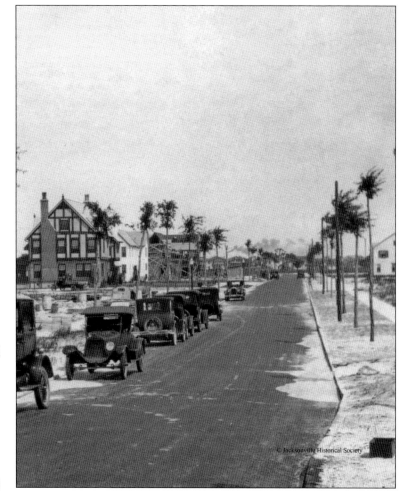

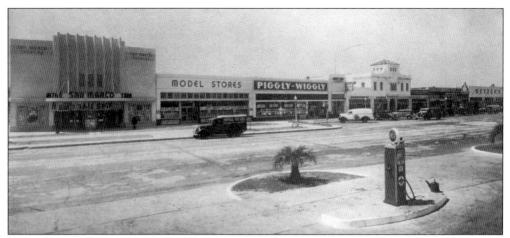

After the St. Johns River Bridge was completed in 1921, the south side of the river became a desirable place to build. Developer Telfair Stockton designed San Marco after being inspired by a visit to the Piazza di San Marco in Venice, Italy. The late-1930s photograph above shows early San Marco Square with Setzer's grocery on the far right and the San Marco Theater on the left. With 100,000 square feet of floor space, Setzer's grocery was one of the largest food stores in the south. A gas pump and watering can from the Gulf station are clearly visible in the foreground. The 1926 Mediterranean Revival–style St. Marks Building (below) was the first structure constructed in the square. Its tenants have included a drugstore, a restaurant, and a longtime occupant—The Towne Pump. (Below, courtesy of Judy Davis.)

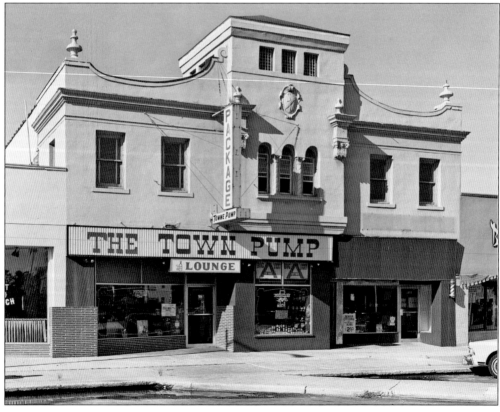

The new development of San Marco was advertised in 1925 with a full-page spread in local newspapers, touted as "a veritable garden spot with its tropical beauty and natural advantages." At this time the Florida land boom was in full swing, and every lot in the 80-acre subdivision sold in one day. (Courtesy of Philip W. Miller.)

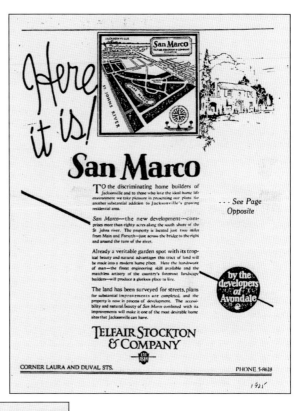

Spanning another full page, immediately opposite the previous advertisement for San Marco, the company apologizes that all the lots were sold prior to the date when sales were officially scheduled to begin. The next to last paragraph reads in part: "We regret to the fullest extent that we were not able to afford all of our friends an opportunity to buy in San Marco." (Courtesy of Philip W. Miller.)

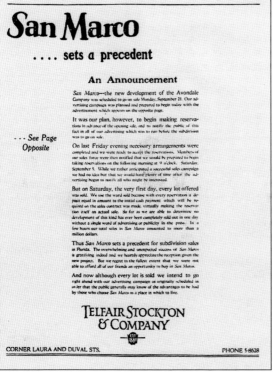

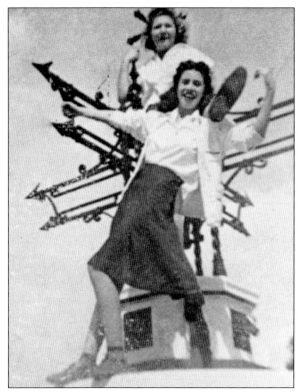

Two Landon High School students pose on the San Marco fountain's compass ornament in 1940. This well-known landmark has always served as the centerpiece of San Marco Square. Over the years, several generations of Landon students have honored a tradition of putting soapsuds in the fountain. The metal compass sculpture seen here was saved when the fountain was replaced in 1987. It was reinstalled atop the monument that stands at the northern end of the square, located at the intersection of San Marco Boulevard and Naldo Street. In 1964, the fountain had a $4,800 Plexiglas dome placed over it to prevent ladies' beehive hairstyles being ruined by the fountain's spray. The dome was removed several years later. The 1980s photograph below shows the fountain—without the dome—being used as a planter. (Below, courtesy of Judy Davis.)

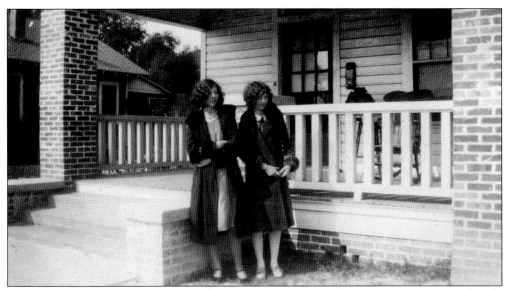

This photograph from the late 1920s shows Genevieve and Lorraine Patterson standing beside their front porch on LaSalle Street. They are both wearing fashionable fur-trimmed coats, indicating that the picture was probably taken during a winter month in San Marco. The house in the background on the left is no longer standing. It was replaced by an apartment building in the 1950s. (Courtesy of J. L. White.)

Sarah Ann Bayer and Alvin Bayer are seen here in an undated photograph. The small child on the right is unidentified, as is the church building visible in the background. Exactly where the picture was taken is a mystery, but the children may be sitting somewhere near Lasalle Street. (Courtesy of J. L. White.)

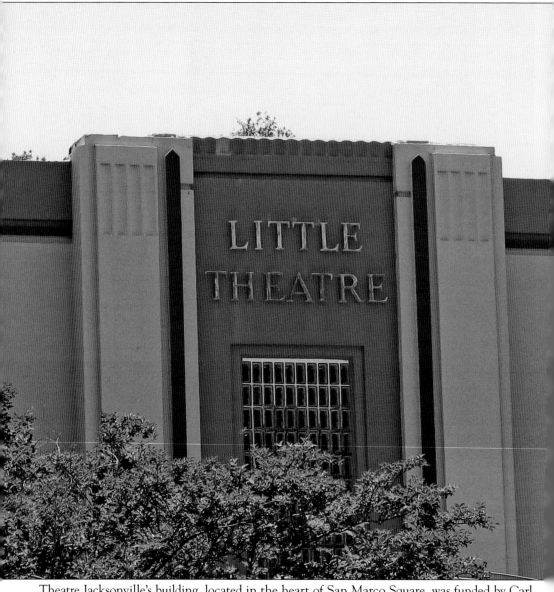

Theatre Jacksonville's building, located in the heart of San Marco Square, was funded by Carl Swisher and designed by Ivan H. Smith. In 1991, it was added to the National Register of Historic Places. Groundbreaking for the Little Theatre building took place on August 14, 1937. On January 18, 1938, the first season in the new playhouse began with the play *Boy Meets Girl*. The playbill for the evening stated: "The Little Theatre of Jacksonville is the proud owner of one of the finest and best equipped Little Theatre buildings in the country." Only a few years later, during the 1940–1941 season, a tragic event occurred when actor Richard Hollahan died onstage while performing the role of Zeke the butler in the comedy *Fashion*. He had just pulled up a chair and began speaking his lines when he collapsed to the floor. The curtain closed, and the performance was immediately cancelled. Whether Hollahan is the ghostly figure wearing a bowler hat that appears on the lobby staircase remains a mystery.

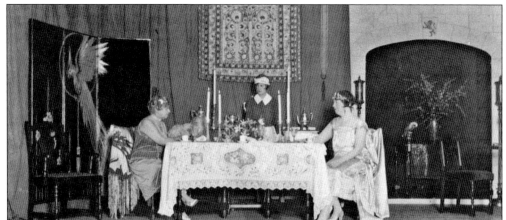

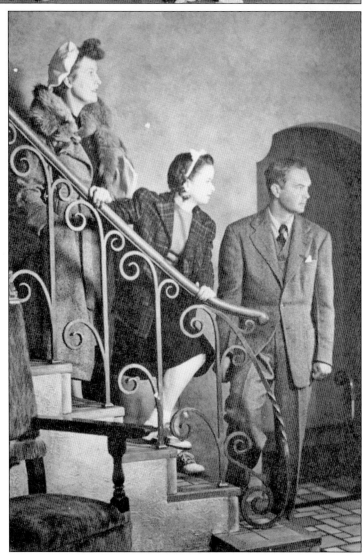

Mr. and Mrs. E. R. Hoyt were the founders of The Community Players of Jacksonville. Described as being "vibrant and attractive," they brought their experience of working with a community theater in Maine to Jacksonville in 1919. During the 1925–1926 season, The Community Players of Jacksonville was renamed the Little Theatre of Jacksonville, and in 1972 the name was changed again to Theatre Jacksonville. Mrs. Hoyt is pictured above, seated on the left, performing in an unidentified play sometime during the 1920s. The other two women are unidentified. The photograph at right shows three unidentified Little Theatre actors posing on the staircase. They performed in the play *Kind Lady* during the 1942–1943 season. (Courtesy of Theatre Jacksonville.)

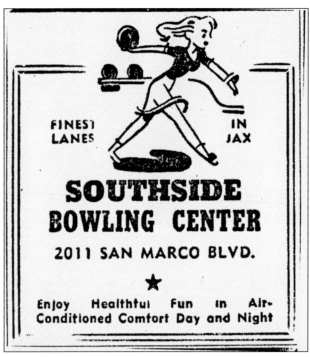

FINEST LANES IN JAX

SOUTHSIDE BOWLING CENTER

2011 SAN MARCO BLVD.

★

Enjoy Healthful Fun in Air-Conditioned Comfort Day and Night

This advertisement appeared on August 15, 1945. The Southside Bowling Center was located at 2011 San Marco Boulevard in San Marco Square, approximately where the Bank of America drive-through tellers are today. The air-conditioned comfort mentioned in the advertisement was still a rarity for the time. (Courtesy of Bill and Margot Bonner.)

This 1980s photograph was taken at the corner of Naldo Avenue and San Marco Boulevard. The apartment buildings visible in the background are on the northwestern corner, just across the street from San Marco Square. The car in the foreground is a 1981 Toyota Starlet, a model that was produced between 1973 and 1999, and only sold in the United States from 1981 to 1984.

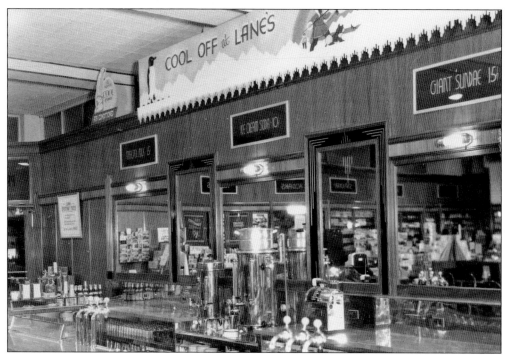

Lane's Drugstore was located on San Marco Boulevard, approximately where the Bank of America building stands today. It was one of several pharmacies located in the area. Its soda fountain, a popular spot for Landon Junior and Senior High School students, is pictured here in 1935. (Courtesy of the State of Florida Archives.)

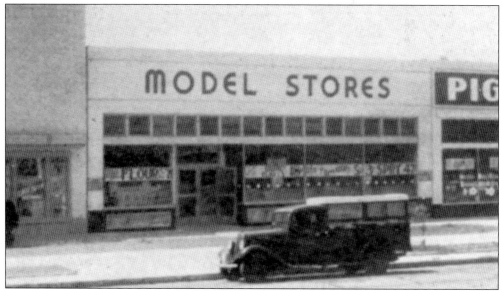

Located between the San Marco Theater and the Piggly Wiggly is Model Stores, Inc., that sold groceries and meats. Over the years, this site was home to Agee and Mundy Drugs (1940–1941), Murphy-Mundy (1942–1943), Lockwood Drugs (1944), Carleton Drugs (1946–1950), Lowes Cut Rate Drugs (1951–1970), Health Nut House (1971–1981), and in 1985 it housed Whites card shop's new addition.

This aerial photograph shows San Marco Lake in the 1950s. The lake was the former brick pit used by the Gamble and Stockton Company. Here clay was excavated, molded into bricks, and transported via tramcar down Sorrento Road to the FEC railroad tracks. The bricks were used in the construction of many of the houses in San Marco. (Courtesy of the State of Florida Archives.)

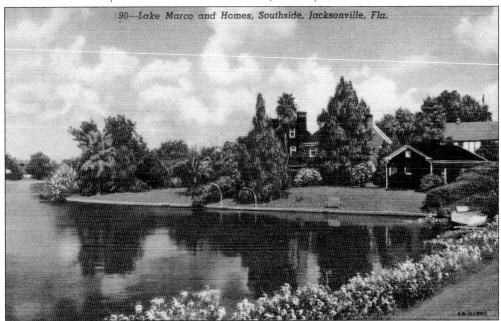

When Telfair Stockton developed San Marco, he dredged a canal from the brick pit to the river and created the picturesque San Marco Lake. This postcard, dated 1948, shows the south end of the lake with surrounding bushes in full bloom. A notation on the back of this postcard, originally mailed to Baltimore, reads: "Arrived safe, lovely trip, all well."

This 1940s photograph shows an unidentified woman standing in the doorway of her Tudor-style home on Sorrento Road. She is awaiting a delivery man from a diaper service. At this time, the shaded, tree-lined Sorrento Road of today had yet to develop. (Courtesy of the State of Florida Archives.)

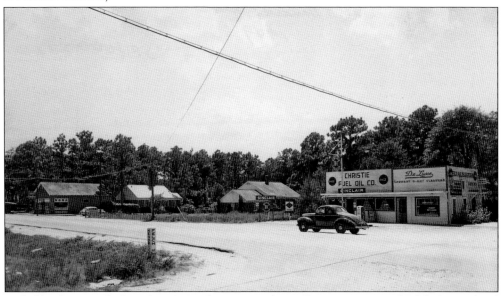

Probably photographed in the 1940s, this picture shows the intersection of Felch Avenue and Hendricks Avenue. On the right side of the picture is Christie Fuel Oil Company and Sinclair gas station. This block on the western side of the street now houses Beard's Jewelry. The brick building visible on the far left is the current Metro Diner. (Courtesy of the State of Florida Archives.)

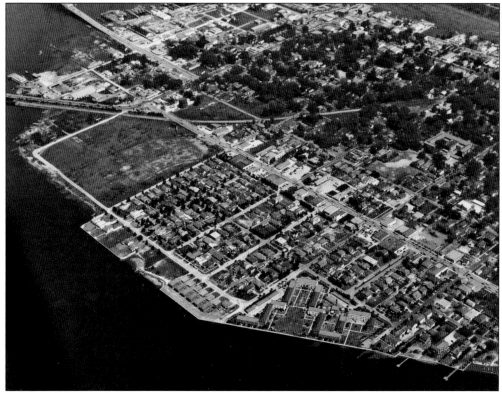

This aerial photograph of the western side of San Marco was probably taken in the 1940s. In the bottom foreground, the angled set of buildings is the Catherine Court Apartments. This complex was renovated in the 1980s as the Alexandria Condominiums. Also clearly apparent is the large tract of vacant land where the Baptist Medical Center complex now stands.

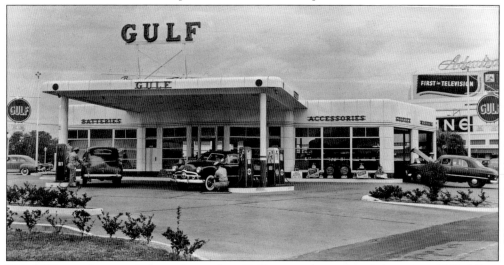

This 1950s-era photograph shows the modern Gulf station that replaced the unique 1920s filling station pictured on the cover. A Gulf station was maintained at this location until the 1980s, when the site was razed and Balis Park was built. For many years, its proprietor was P. M. Rousseau. (Courtesy of the State of Florida Archives.)

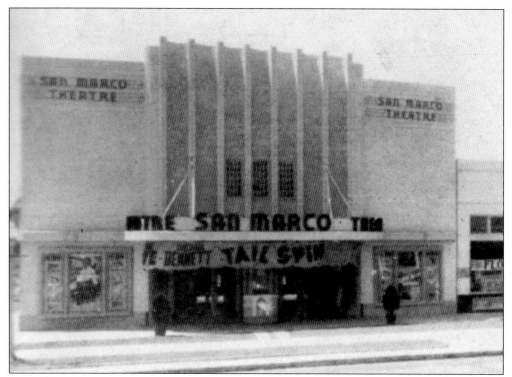

According to an account in *Theatre Jacksonville, A History of a Little Theatre* by Gerri Levine Turbow, the San Marco Theatre (pictured above in 1939) was originally referred to as Spark's moving picture theater. It was built in 1938 and designed by architect Roy Benjamin, who was also responsible for the beautiful Florida Theater in downtown Jacksonville. Instead of conforming to the prevailing Italian and Moorish style of the existing buildings in San Marco Square, he used a design of the times: art deco. Like many old theaters, this one too is reputedly haunted. Those working late in the building have reported seeing a transparent figure, perhaps the ghost of a theater manager who died in his office. The photograph below shows the theater more than 50 years later.

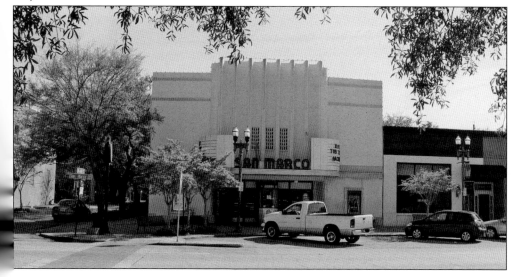

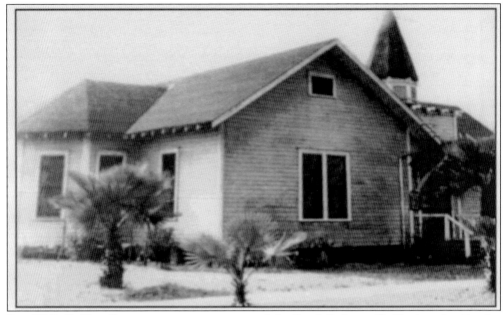

Rev. W. B. S. Chandler, assistant pastor, organized the South Jacksonville Presbyterian Sunday school in 1913. Out of this school came the South Jacksonville Presbyterian Church, officially organized on November 9, 1913, with 23 charter members. The frame church seen here was built for the congregation in 1915. It was located on the southwest corner of LaSalle Street and Hendricks Avenue, now the site of Regions Bank. (Courtesy of the South Jacksonville Presbyterian Church.)

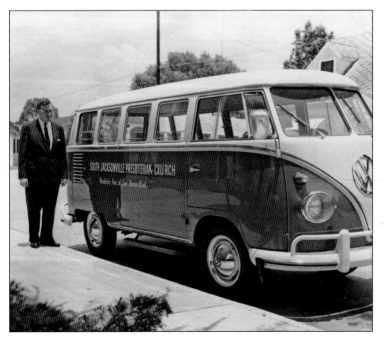

David Seabrook, associate pastor, is seen here in the 1950s, standing beside the church's VW van. The vehicle may be parked on Thacker Avenue, behind the church, at its current location at the intersection of Hendricks Avenue and San Marco Boulevard. That portion of Thacker Avenue is closed off today, and the houses visible in the background no longer exist. (Courtesy of the South Jacksonville Presbyterian Church.)

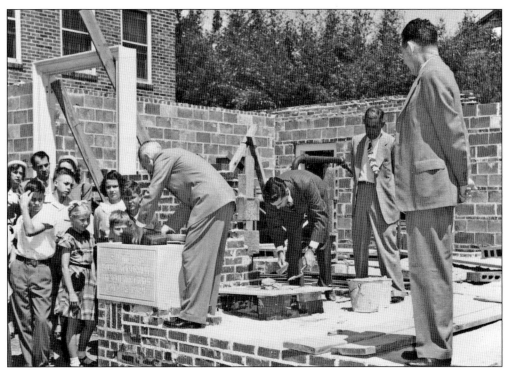

On April 2, 1949, the cornerstone was laid in the partially completed South Jacksonville Presbyterian Church. Leaning over the stone is Dr. Steven T. Harvin, pastor. He appears to be placing a time capsule in the cornerstone. The onlookers are unidentified. (Courtesy of the South Jacksonville Presbyterian Church.)

In 1949, the momentous occasion of placing the steeple atop the new South Jacksonville Presbyterian Church occurred. That moment in time is shown here, a swaying portion of the steeple attracting the attention of onlookers and bicyclists. A corner of the original Educational Building is visible on the left. (Courtesy of the South Jacksonville Presbyterian Church.)

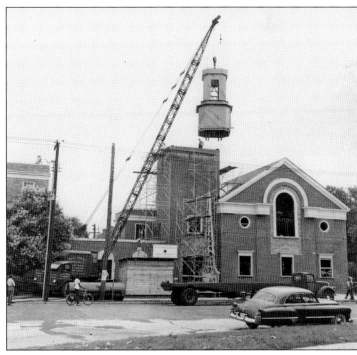

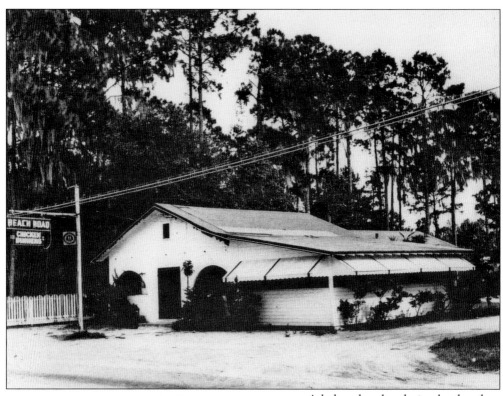

A beloved and enduring landmark for many San Marco residents is Beach Road Chicken Dinners, which still operates out of its original building on Atlantic Boulevard. The above photograph shows the restaurant in its early days, when Atlantic Boulevard was the only route from South Jacksonville to the beaches. Earl Majors (left), a native of England, moved to Jacksonville from West Palm Beach and founded the business in 1939. He employed slender waitresses, who were required to wear crisp white uniforms with cinched waists. Those uniforms are long gone now, but the restaurant still serves up bountiful portions of its famous fried chicken dinner, a favorite for generations of Jacksonville residents. (Courtesy of Beach Road Chicken Dinners.)

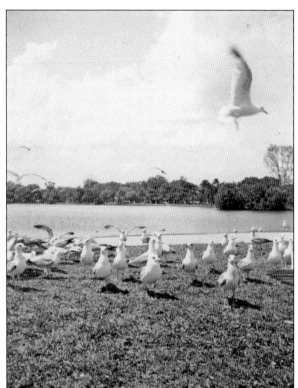

A popular stop for families carrying bags of bread crumbs is Colonial Park Lake, commonly called "The Duck Pond," located on Old San Jose Boulevard south of the San Marco area. The photograph at right, taken in the 1940s, indicates that seagulls also find it an inviting place to visit. Young Connie Peek, seen below wearing her Bishop Kenny school uniform, offers a snack to the resident ducks. Local lore states that this body of water was originally the clay pit from which the bricks for Red Bank Plantation were mined. (Courtesy of J. L. White.)

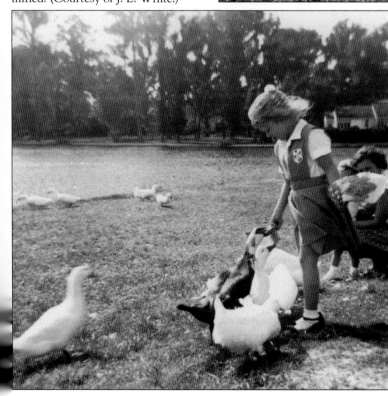

Landon Junior and Senior High School was built in 1927. This beautiful Mediterranean Revival structure by architects Marsh and Saxelbye originally had a tile roof, barely visible in the photograph. When the new school was dedicated, Julia Landon was a special guest at the ceremony. Until Landon Junior and Senior High School was built, South Jacksonville students had to cross the river to attend Duval High School in downtown Jacksonville.

JUNIOR PROM
1926

H.O.T. S.O.T.

OFFICERS
JUNIOR GIRLS CLUB

PRESIDENT:
Miss DOROTHY LEE BROWN
VICE-PRESIDENT:
Miss ANNETTE WHITE
SECRETARY:
Miss RUTH WASHBURN
TREASURER:
Miss DIXIE SHEFTALL
CHAPLAIN:
Miss JOSEPHINE FAIRCHILD
SERGEANT-AT-ARMS:
Miss ANNE E. OVERSTREET
MASCOT:
Mr. ALVIN McCRANIE

OFFICERS
JUNIOR BOYS CLUB

PRESIDENT:
Mr. JAMES NOLAN
VICE-PRESIDENT:
Mr. JOHN BRYSON
SECRETARY:
Mr. ALBERT BARKER
TREASURER:
Mr. DICK JUDY
CHAPLAIN:
Mr. JOHN IMESON
SERGEANT-AT-ARMS:
Mr. HORACE MARSH
MASCOT:
Miss ANNETTE WHITE

Seen here are sample pages from a 1926 dance card. This card was produced for the Duval High School's Junior Prom. It was the last year South Jacksonville students attended the school. Duval High School closed in 1927. After that, pupils could go to school close to home at the new Landon Junior and Senior High School located on Thacker Avenue. (Courtesy of J. L. White.)

Principal William Turney (left) and assistant principal James McCord were the first administrators of the new Landon Junior and Senior High School. They were still at the helm 10 years later as documented by the above photographs taken from the 1938 *Landonian* yearbook. In 1941, James McCord became principal. (Courtesy of Bill Bonner.)

Orra Eastburn was the first dean of girls at the new Landon Junior and Senior High School. It was a position she had for many years. She held a bachelor of arts degree from Carleton College and a master of arts degree from Columbia University.

This is a composite photograph of the Landon Junior and High School faculty of 1938. They are, from left to right, (first row) Lelia Alexander, Jess Armstrong, Mildred Greene, Pauline Greer, and Virginia Southard; (second row) Winnie D. Bacon, Harold U. Besse, Grace Haag, Clara Harper, and Frances R. Thompson; (third row) Ola H. Brooks, Viven M. Brown, Beulah D. Harwell, Elizabeth Hoagland, and Gertrude Wall; (fourth row) Charlotte B. Buckland, Zada Chew, Bernice Holcombe, Eleanor Howell, and Beulah Milam Warner; (fifth row) May Franklin, Ethel E. Fehr, Frances A. Kellam, Nell Kelly, and Margaret Willis. Gertrude Wall, May Franklin, and Winnie D. Bacon were part of the original faculty from 1927 to 1928, and Winnie D. Bacon was still teaching home economics at Landon in 1965.

This is another composite photograph of the Landon Junior and High School faculty of 1938. They are, from left to right, (first row) Betty W. Starbuck, Betty Peck, Harriet Polk, Marilouise Fagg, and Alice Woodward; (second row) George Trogden, Fred Rahaim, Rica Raymond, Lucy Grace, and Rita Nicholl; (third row) Kathleen Turner, Martha Reddick, Pauline Richardson, Ina Land, and Evelyn Nicholl; (fourth row) Ethel West, Charles Romine, Elmore Saare, Rose H. Lapeyre, and Jeanette Ossinsky; (fifth row) Kenneth M. Wing, Percy E. Harry, Gladys Leavitt, Memphis Wood, and Mary T. Parker.

The Landon Girls' Ensemble was formed in 1937 under the direction of Gladys Leavitt. According to an account in the 1941 *Landonian*, they sang everything from "beautiful classical pieces of the masters to the swaying songs of modern times." From left to right are (seated) Martha Permenter, Mary Sue Miller, Sarah Lou Howes, and Marjorie Lay; (standing) Mabel Foster, Mary Warth, Iva Louise Nesmith, and Wynelle Buchanan. A page at the end of the 1941 *Landonian* yearbook lists the following fads: "Skipping Classes, Catching measles, Crossing the deadline, Learning the Conga, Going to Mrs. Jones', Courting favor of faculty, Politicking for elections, Playing off sick, Snatching sweaters, Getting married." The picture below shows several unidentified Landon students practicing their swing. The houses visible behind them, on Thacker Avenue, are still in existence.

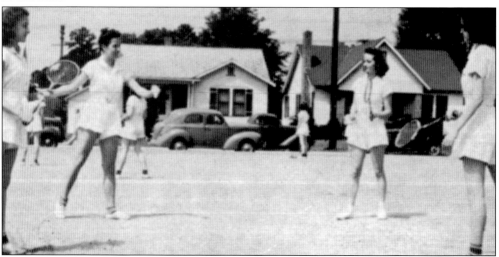

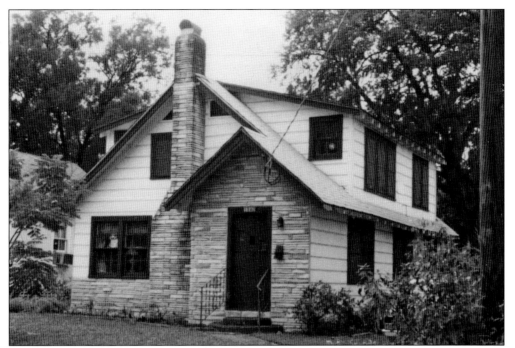

Built in the 1920s, this was one of the first houses constructed on Myrtle Avenue (now Thacker Avenue). At that time, the northern end of Myrtle Avenue terminated at the South Jacksonville Railroad Depot. Today that segment of the street no longer exists, and the land is home to the San Marco Branch Library's parking lot and a portion of the Southside Tennis Courts.

The Southside Branch Library opened on January 2, 1950, on the northeast corner of LaSalle Street and Hendricks Avenue. In 1992, the name was changed to the San Marco Branch of the Jacksonville Public Library. The building was renovated and expanded as part of the Better Jacksonville Plan, and the structure grew from 7,450 square feet to 19,000 square feet, with part of the addition encompassing the new Balis Community Center. (Courtesy of Jacksonville Public Library.)

A true snapshot in time is this 1950s view of the playground on the north side of South Jacksonville Presbyterian Church. Visible behind the playground is the modern, glassed-in pedestrian walkway connecting the drive-through tellers to the Atlantic National Bank. The bank buildings and everything else on the block were razed in 2007 to prepare for a new development called San Marco East. (Courtesy of South Jacksonville Presbyterian Church.)

The aerial walkway across Thacker Avenue was photographed just weeks before it was torn down in 2007 and that portion of the street permanently closed. The building complex was then home to Wachovia bank, but the drive-through tellers had not been used as such for many years. Wachovia relocated to a new building on Atlantic Boulevard, between Mango Place and Minerva Street, a short distance away.

Five

SOUTHBANK'S CHANGING FACE
YESTERDAY AND TODAY

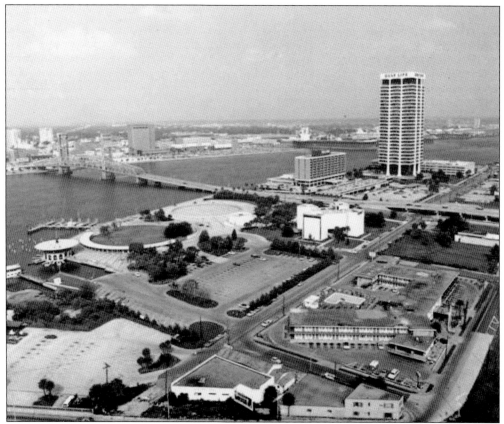

Seen here in 1978, the Southbank has experienced some of the most dramatic changes in San Marco. From Dixieland Park in the early 1900s, to a booming industrial and shipbuilding center mid-century, to today's eclectic mix of hotels and high-rises, the Southbank continues to evolve. In 2005, it underwent a particularly overwhelming but brief transformation as the site of the Super Bowl experience, attracting thousands of visitors from across the country.

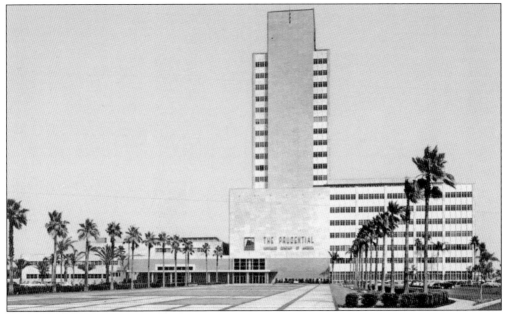

The 300-foot-high, 22-story Prudential Building was dedicated on May 7, 1955. For many years the building served as the South-Central home office for the Prudential Insurance Company. A brochure from the period states: "Pretty Prudential girls serve as guides on free building tours Monday through Friday at 10:30 a.m. and 3:00 p.m."

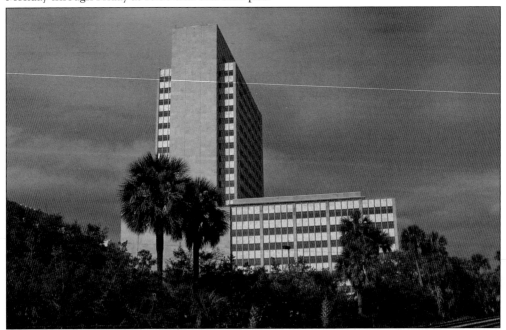

Those who attended the groundbreaking of the Prudential Building were Carroll M. Shanks, Prudential president; Charles W. Campbell, Prudential South Central vice president; George Potter, vice president in charge of construction projects; James H. Coppedge, chamber of commerce president; James R. Stockton, chairman of the chamber's Committee of One Hundred; and mayor of Jacksonville, Haydon Burns.

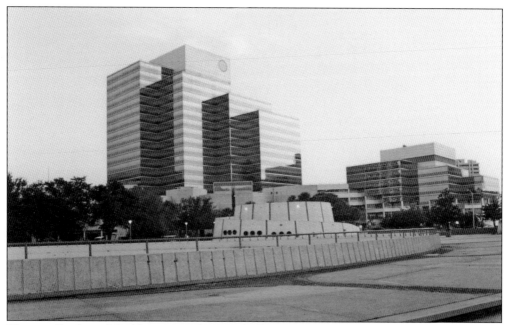

The new Prudential Building is seen here in the late 1980s with the Friendship Fountain visible in the foreground with its arching cascades of water turned off. The round Prudential logo at the top of the Prudential Building was lowered into place via helicopter as the structure neared completion. (Courtesy of Junius.)

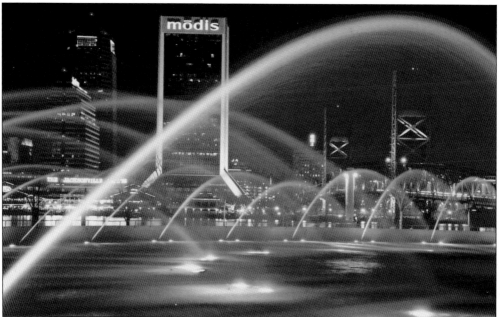

Friendship Fountain's original name was the Fountain of Friendship in Dallas Thomas Park. It opened in 1965 and was touted as the world's largest and tallest fountain. The park was named for a local commissioner who unfortunately ended up embroiled in a civic scandal. Thus, the park and its fountain were renamed. This nighttime view shows the fountain with the Modis Building (formerly Independent Life) in the background. (Courtesy of Stephen J. Smith.)

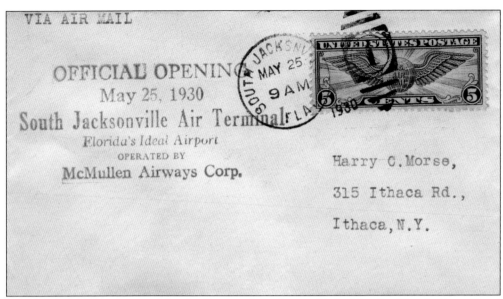

VIA AIR MAIL

OFFICIAL OPENING
May 25, 1930
South Jacksonville Air Terminal FLA
Florida's Ideal Airport
OPERATED BY
McMullen Airways Corp.

Harry C.Morse,

315 Ithaca Rd.,

Ithaca,N.Y.

According to an account in *Florida: Empire of the Sun*, published by the Florida State Hotel Commission, South Jacksonville had an airport located "almost in the heart of the business section." As documented by the above event cover, it opened on May 25, 1930. The airport leased space on the site of the former ostrich farm, where the Aetna (Prudential) Building now stands. It served as a short hop airport and also as a center for pilot training and airplane sales. It operated only until 1931.

This photograph from the 1940s provides a view of the site where the South Jacksonville Air Terminal existed for a brief moment in time. The vacant tract in the foreground became home to the Baptist Medical Center in the 1950s. Visible on the right side of the photograph are the FEC railroad tracks and San Marco Boulevard.

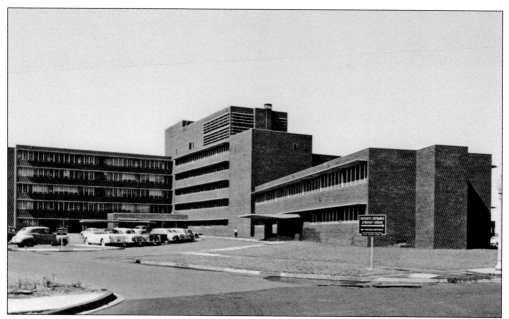

On September 26, 1951, it was reported by the *Miami News* that "the Jacksonville Baptist Memorial Hospital construction fund was given $20,000" by the St. Joe Paper Company, bringing the fund up to $420,000. The hospital is seen above in a 1950s postcard soon after its completion. By the early 1990s, the name was changed to Baptist Medical Center Downtown. The sign in the foreground reads: "Patients Entrance Straight Ahead."

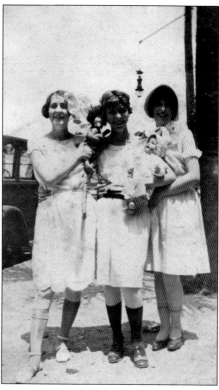

Until Baptist Memorial Hospital was built, South Jacksonville residents traveled across the river to St. Vincent's Hospital if they required serious medical care. St. Vincent's Hospital also had a nursing school. This 1930s photograph shows three unidentified nursing students enjoying their free time by clowning around, dressing up, and posing with baby dolls. Note the suspended streetlight in the background. (Courtesy of J. L. White.)

The enduring Treaty Oak (above) is seen here in a 1940s postcard view. Today it still commands a place of honor in the Southbank area as the centerpiece of Jessie Ball duPont Park. The tree is a huge, spreading Southern live oak, estimated to be over 200 years old. As seen in the postcard below, in the early 1900s, it was a major attraction at Dixieland Park, its branches festooned with hundreds of electric lights. Beneath this tree John Philip Sousa and his band gave a concert. (Below, courtesy of the Jacksonville Public Library.)

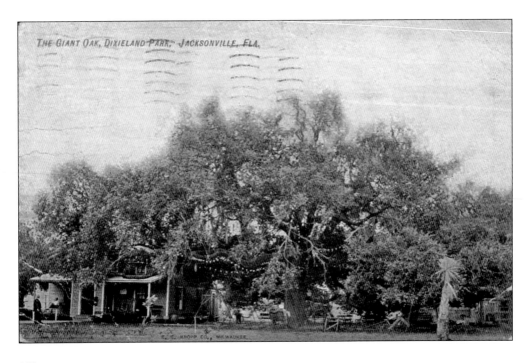

A popular landmark on the Southbank is the Museum of Science and History (MOSH). Madge Wallace (left) and Madeline B. Sawyer are seen here standing in front of an exhibit. Wallace was one of the three original founders of the Jacksonville Children's Museum, and Sawyer was the first director. (Courtesy of the Museum of Science and History.)

From 1948 through 1964, the Jacksonville Children's Museum was located in this older building in Riverside. Years after the move across the river, the Jacksonville Children's Museum became the Jacksonville Museum of Arts and Sciences (in 1977). In 1988, it was again renamed to the Museum of Science and History. (Courtesy of the Museum of Science and History.)

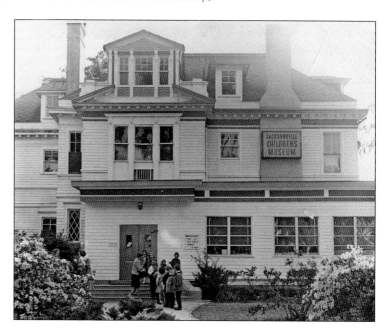

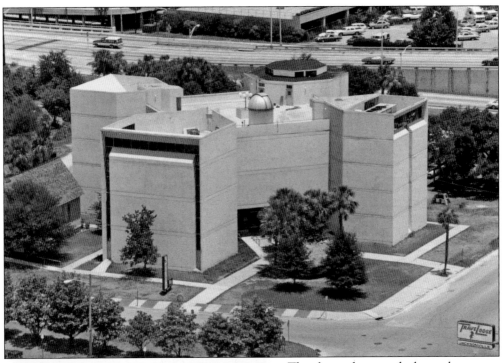

The above photograph shows the museum's new building on the Southbank in the 1970s. This is the structure residents know today as the Museum of Science and History. Visible in the lower right corner is the sign for the old (now demolished) TraveLodge motel. On the left side, half hidden behind a tree, is the small Gothic church that was moved from the St. Paul's Episcopal Church property on Atlantic Boulevard. The photograph at left shows Alexander Brest in 1988 when 37,500 square feet of space was added to the museum, including the new Alexander Brest Planetarium, originally called the Alexander Brest Space Theater. The planetarium features an overhead dome-shaped projection screen that reveals the wonders of the stars and planets, all accompanied by an eclectic musical soundtrack. After renovations are completed in October 2010, the facility will reopen with a new name: The Bryan Gooding Planetarium in the Alexander Brest Science Theatre. (Courtesy of the Museum of Science and History.)

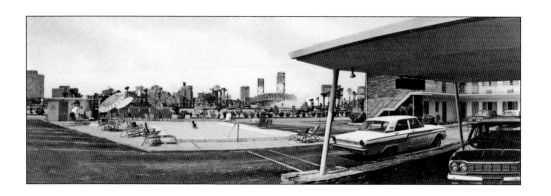

Taken from a 1960s-era postcard, this is a unique view of the TraveLodge motel's swimming pool. The background shows a portion of the Southbank at a time when there were no buildings on Riverplace Boulevard between the motel and the river. Guests sunning themselves beside the pool had a beautiful view of the downtown skyline, the Main Street Bridge and Friendship Fountain. Soon after this picture was taken, the Jacksonville Children's Museum was built across the street from the TraveLodge, and a few years after that, the TraveLodge was torn down. Today this property houses buildings of the new Prudential complex. The 1960s-era photograph below was taken from across Riverplace Boulevard and shows the TraveLodge motel, as visitors would have seen it upon their arrival.

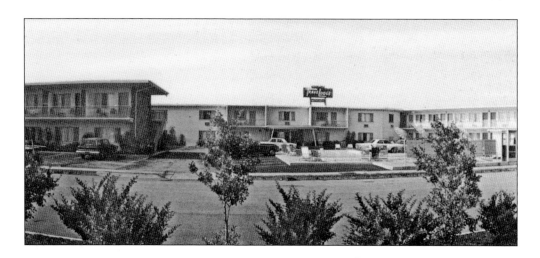

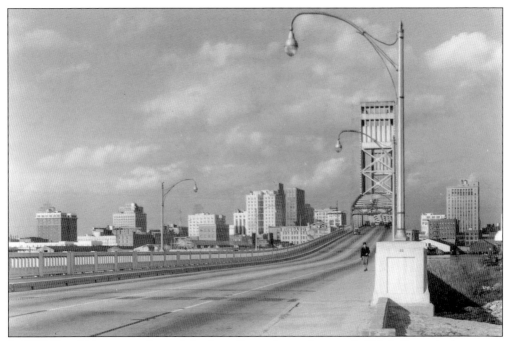

In 1938, Duval County condemned the ferry slips at the southern end of Main Street in downtown Jacksonville and purchased the property for $50,000 for the purpose of building a new bridge linking the north and south sides. The Alsop Bridge, more commonly known as the Main Street Bridge, opened on July 18, 1941, with the ribbon cut by Governor Holland. The above photograph clearly shows the bridge and its modern expanse of asphalt that replaced the once critical ferry service. The ferry used to depart from this same location on the south bank of the river. The photograph below shows the Main Street Bridge viewed from a rooftop in downtown Jacksonville. Just visible in the distance, behind the bridge upright, is the old Dixie Theater building—the last vestige of the once splendid "Coney Island of the South."

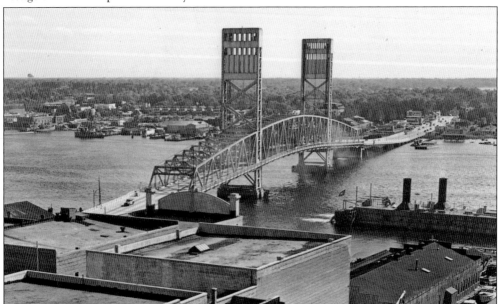

South Jacksonville resident and plumber Herman Greelish is seen here standing near one of his larger projects. The building behind him is the old Flagler Hospital in St. Augustine that was constructed in 1921. In the 1950s, the south wing was remodeled, and Herman Greelish traveled there to lend his plumbing skills to the project. (Courtesy of J. L. White.)

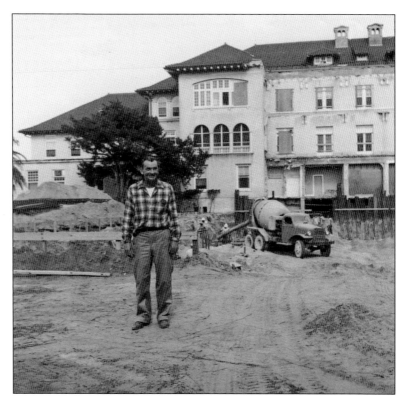

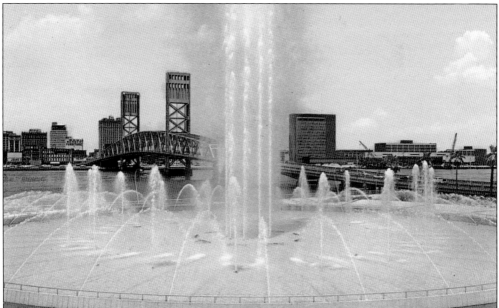

A significant example of Herman Greelish's work is still enjoyed by people today as they stroll along the Southbank. When they pause to admire the view and feel the fountain's mist on their faces, they have Herman Greelish to thank. It was Herman, along with his brother Roy Greelish, who did the plumbing that makes Friendship Fountain's beautiful arching cascades possible. This postcard shows Friendship Fountain soon after it was completed.

The Gulf Life Tower, now called Riverplace Tower, was built in 1967 on land that once housed part of the Gibbs Corporation. Its dedication ceremony in December 1967 included fireworks, an open house, and a medical forum. Referred to as "the Tower of the Future," it was then the tallest building in Jacksonville, soaring 433 feet above the St. Johns River. The concrete grid of the building's exterior provides the support needed for the structure, leaving its full interior available for use. Architect Welton Beckett said the walls were constructed to create a "rhythmic undulation" of light and shadow. After the Gulf Life Tower was completed, a rumor circulated that Jeanne Dixon, a famous psychic of the day, predicted that the structure would collapse into the river. She denied having made that prophecy. This late-1980s nighttime photograph shows the Gulf Life Tower appearing to rise from behind the silhouette of the former Hilton Hotel. (Courtesy of Junius.)

This is a photograph of the Treaty Oak (see page 102) from the late 1930s or early 1940s. This spreading oak tree has been a silent witness to many moments in history. During the days of Dixieland Park, it sheltered celebrities, daredevils, and tourists. Today it appears to stoically accept the steady din of nearby expressway traffic. The early automobile in this picture was a harbinger of things to come.

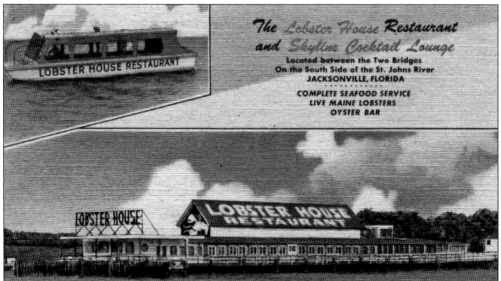

The Lobster House Restaurant was a landmark for Jacksonville residents for many years, providing diners with a beautiful view of the Jacksonville skyline. Originally built as a boat repair shop, the structure was renovated as the Lobster House Restaurant in 1944. Today the River City Brewing Company restaurant occupies that general location and has an equally impressive view. The Lobster House Restaurant was destroyed by fire in 1962.

In the 1950s, the Lobster House Restaurant went down in local history for its part in the filming of *Revenge of the Creature*, the sequel to the classic film *The Creature from the Black Lagoon*. The Lobster House scene was filmed at night and featured the dramatic moment when the Creature (Tom Hennesy) abducts the heroine (Lori Nelson) from the restaurant. Actress and underwater performer Ginger Stanley portrayed the heroine in the water scenes. During the filming, the strong tidal flow of the St. Johns River and an abundance of jellyfish almost caused a tragedy. After they jumped into the water, the two actors became caught in the current and were nearly swept away. All ended well when two young people who had been watching the filming from a boat stepped in as rescuers. (Above, courtesy of Universal International Showman's Manual.)

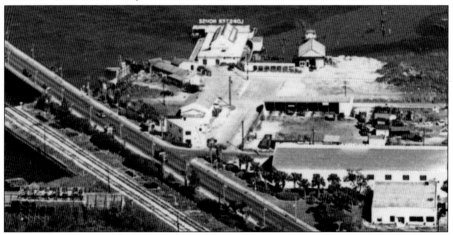

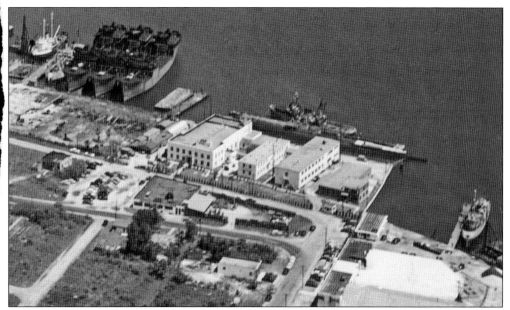

This aerial photograph from the 1940s shows the Naval Reserve Training Station, located on the riverfront on Morse Street (Riverplace Boulevard) between Hendricks Avenue and Bugbee Street, just east of the Gibbs Corporation main plant. Bugbee Street no longer exists, and that area now houses Morton's Steakhouse.

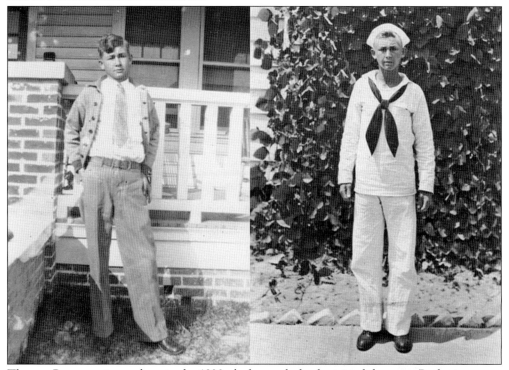

Thomas Patterson is seen here in the 1930s, before and after he joined the navy. Both views were taken during the 1930s, when Thomas was just 16 years old. He is standing in the yard of his home on LaSalle Street. (Courtesy of J. L. White.)

In this 1980s interior view of the Museum of Science and History, three unidentified visitors enjoy a display featuring "The Magic of Recycling" and "Look into Your Future." Completing this meeting of the eras is a vestige from the distant past: a dinosaur skeleton. (Courtesy of the Museum of Science and History.)

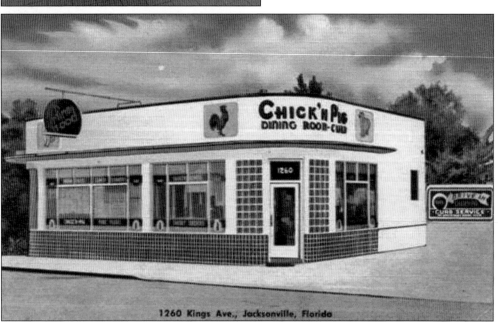

1260 Kings Ave., Jacksonville, Florida

This postcard features the Chick 'N Pig Dining Room. According to the sign in the rear, this establishment also offered a "drive-in" and "curb service." This location on the northwest corner of Kings Avenue and Nira Street is now home to the parking lot of CenterBank of Jacksonville. This postcard dates from the mid-20th century when Kings Avenue was a popular tourist route.

Six

VANISHINGS AND NEW BEGINNINGS
SAN MARCO THEN AND NOW

Portrayed here are two bridges in time; the old Florida East Coast Railway Bridge on the left is dwarfed by the looming structure of the new Acosta Bridge on the right. Both bridges are still in use today, but the original St. Johns River Bridge exists here now only in memory, a ghost of the past that in 1921 changed the future of Jacksonville forever.

Its shutters closed, the St. Nicolas Station appears to be waiting patiently for its new life to unfold. In 2005, it was moved from Linden Avenue to Atlantic Boulevard across from Assumption Catholic School, becoming the centerpiece of the new St. Nicholas Train Station Park. The station was once a stop on the popular route of the Florida East Coast Railway that ran from South Jacksonville to the beaches.

Tolls have been a fact of life for Jacksonville residents for decades. Above are the tollbooths for the Fuller Warren Bridge (originally called the Gilmore Street Bridge), probably photographed in the 1970s. In the late 1980s, voters agreed to an extra sales tax to eliminate tolls on the bridges. With great fanfare, a wrecking ball was taken to the structure seen above, putting an end to tolls and traffic jams on this heavily traveled route between San Marco and Riverside. (Courtesy of the State of Florida Archives.)

The early days of St. Paul's Episcopal Church date back to 1880 when Harriet Stevens began opening her winter home for worship services (see chapter one). This photograph of the structure was taken in June 1952. In 1927, a parish hall and kitchen were added, followed by tennis and basketball courts. By this time, the church had already been moved twice on the same property, most recently due to the widening of Atlantic Boulevard. This location would be but one of several resting places for the church. (Courtesy of St. Paul's Episcopal Church.)

Taken in the 1950s, this photograph shows a Sunday school class. Visible on the far left is Richard Urban, first rector of St. Paul's Episcopal Church. A portion of the wing that was added to the original church building is clearly visible on the right. (Courtesy of St. Paul's Episcopal Church.)

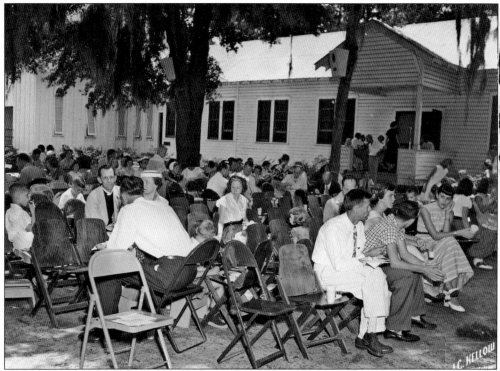

This photograph of a 1950s church picnic shows a more expanded view of the addition on the side of the original building. When the time came to move the church again, this wing was removed. (Courtesy of St. Paul's Episcopal Church.)

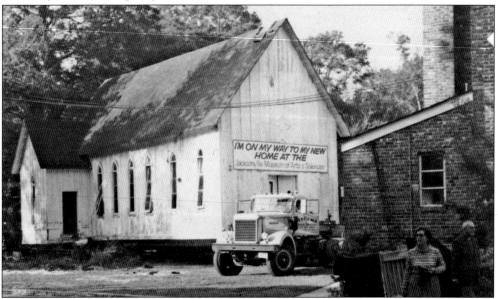

In 1977, the church left its longtime home on Atlantic Boulevard. This time the relocation marked a new identity for the building. It was headed to the grounds of the Jacksonville Museum of Arts and Sciences on the Southbank, to be used as a children's theater. Yet, even this move was not destined to be its last. (Courtesy of St. Paul's Episcopal Church.)

Visiting the church at her new location on the grounds of the Jacksonville Museum of Arts and Sciences are, from left to right, Daniel Wager, Fr. Mark Butler, Fr. Robert Bast, Very Rev. David Rose (retired Bishop of Southwest Virginia), and Michael Spilker. (Courtesy of St. Paul's Episcopal Church.)

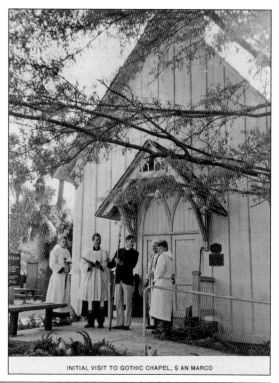

INITIAL VISIT TO GOTHIC CHAPEL, S AN MARCO

Varieties of chickens were often seen running around the church building at its new location and became a favorite of young visitors to the Jacksonville Museum of Arts and Sciences. The birds often wandered over from the log cabin exhibit located behind the church. The historical marker describes the William Bartram Trail. (Courtesy of St. Paul's Episcopal Church.)

On the move one more time, the St. Paul's Church is seen here as it rolls slowly toward Atlantic Boulevard near the I-95 overpass. It was the fourth move for the building, this time relocated from the grounds of the Museum of Science and History (the former Jacksonville Museum of Arts and Sciences) in 1995. (Courtesy of P. Denman.)

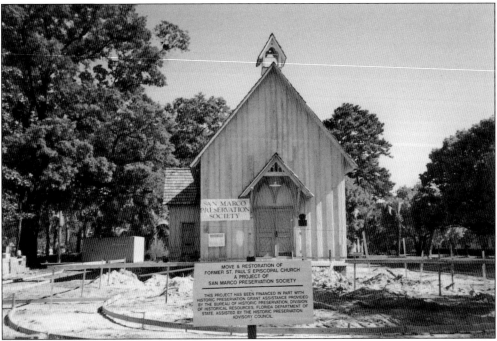

The church is pictured here soon after being settled on the grounds of Fletcher Park (earlier called Belote Park) on April 2, 1995. Today it is owned by the San Marco Preservation Society and is a favorite location for weddings, concerts, and other special events. (Courtesy of P. Denman.)

Lisbon Street, formerly named Park Street, is now only a memory. A short street of only two blocks, its eastern terminus was Flagler Avenue, and the western block ended at the RC Cola Bottling Plant. The houses above, photographed in the 1980s, had a magnificent view of the Jacksonville skyline, and Lisbon Street was a favorite place for local families to gather on the Fourth of July to watch the fireworks. In 1993, all the houses on the street were razed, and the entire area was paved over. It is now part of the Baptist Outpatient Center's parking lot. The photograph below shows the same two lots immediately after the homes were torn down and the debris cleared away. (Above, courtesy of Donald Sloneker; below, courtesy of P. Denman.)

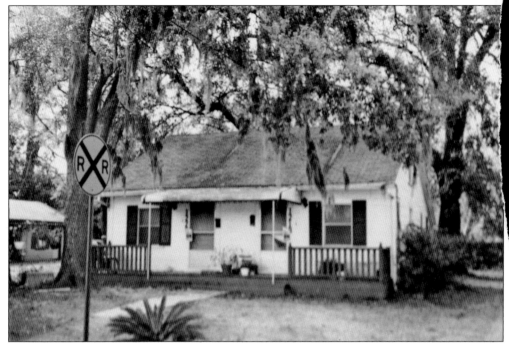

These two photographs illustrate one of the more dramatic changes that occurred in San Marco in a historically short span of time. The small duplex seen above used to sit on the south side of Lisbon Street. It was torn down in 1993, along with all the other houses on the street, to make way for the construction of the Baptist Outpatient Center and its associated parking lot. The photograph below shows the completed Baptist Outpatient Center parking lot—the same location as the house pictured above. Only a few of the trees visible in the above photograph are still standing. (Above, courtesy of Donald Sloneker.)

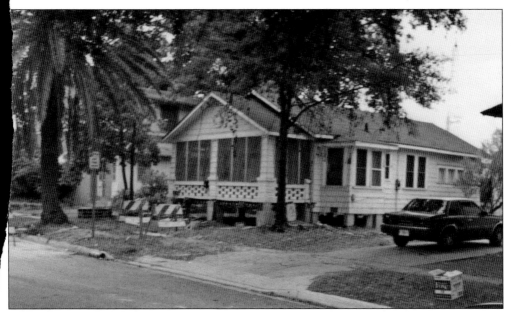

Not every house was demolished when the Baptist Outpatient Center parking lot was built. This home, photographed in June 1993, is shown easing onto its new location on Landon Avenue. It was moved from its original lot on Nira Street, sited just behind the razed houses on Lisbon Street. Somehow it managed to be one of the lucky neighborhood survivors. (Courtesy of P. Denman.)

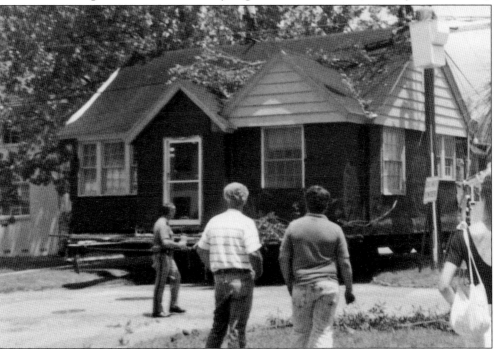

In 1989, this house was moved from its original location on the corner of San Marco Place and Hendricks Avenue to allow for expansion of the First Baptist Church. This photograph shows the building squeezing between obstacles on LaSalle Street en route to its new home. It was relocated to a lot on Flagler Avenue. (Courtesy of P. Denman.)

This brick house was originally located on the northern side of Alexandria Place, facing Brown Whatley Park. It is shown here inching down Arcadia Place, passing by the Landon Middle School track and baseball field, en route to its new home on Landon Avenue. After this home was moved, a larger two-story house was built in its place overlooking Brown Whatley Park. (Courtesy of P. Denman.)

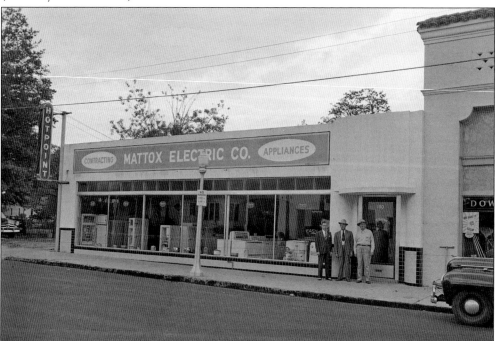

This picture features the Mattox Electric Company and part of the Downing Hardware Store, probably photographed in the 1940s. This 1100 block of Hendricks Avenue between Tidbits Restaurant and the Florida Baptist Convention property no longer exists. It was razed when the I-95 elevated expressway system was constructed. (Courtesy of the State of Florida Archives.)

This 1950s-era photograph shows a brick Gary Street looking eastward toward its intersection with Kings Avenue. The scene below depicts the same intersection more than 50 years later. The building on the right side of the photograph survived the intervening decades, but it has been remodeled many times over the passing years. These pictures clearly illustrate how drastically the landscape was changed when the elevated expressway system was built in 1958. (Above, courtesy of the State of Florida Archives.)

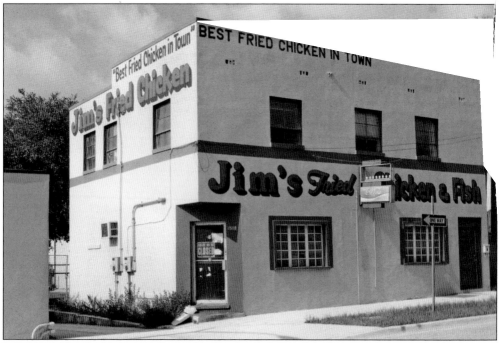

Jim's Fried Chicken restaurant was a landmark on the south side of Gary Street for many years, a popular place for diners to stop for lunch or on their way to or from work. Like the building next door, Jim's Fried Chicken managed to survive the changes that came when the elevated expressway system was built. (Courtesy of William Sundmacker.)

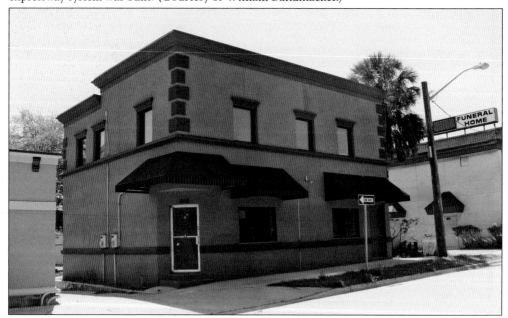

The former Jim's Fried Chicken Restaurant is seen here in a more recent photograph. Naugle Funeral Home is visible on the right, located on the southeast corner of Gary Street and Hendricks Avenue. Gary Street is now bathed in the constant hum of traffic whizzing by on the elevated expressway that is situated directly across the street from this building.

Located on the corner of Kings Avenue (Philips Highway) and Mitchell Place, Howard Biser's Restaurant was a popular place for San Marco diners seeking seafood and "the best cup of coffee in Florida." Today this intersection is located near where the expressway system connects to the northern end of Philips Highway. Howard Biser's Restaurant building no longer exists; instead, the property houses the Scottish Inn.

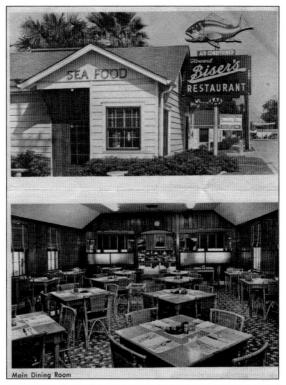

Main Dining Room

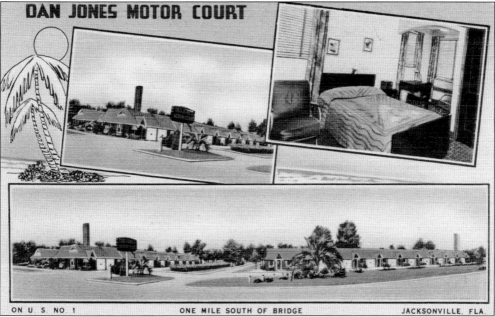

Located south of Howard Biser's Restaurant was Jack Murray's Brick Cabins, which became the Dan Jones Motor Court. The buildings had distinctive arched doorways and steeply peaked rooflines. A portion of the motel managed to survive into the 21st century but was torn down soon afterward, and today the tract of land that once housed the Dan Jones Motor Court is vacant, patiently awaiting a new incarnation.

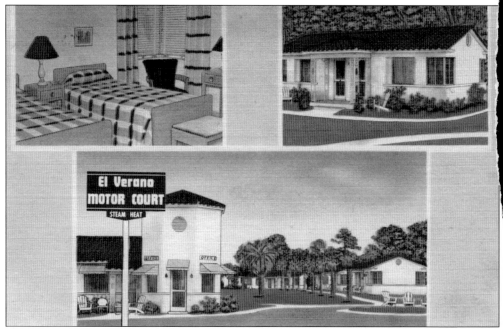

Across the street from Howard Biser's Restaurant and Dan Jones Motor Court was the El Verano Motor Court. Currently occupying this site is a storage unit business. Today the son of El Verano Motor Court's owner has a business of his own in San Marco: Stan's Sandwich Shop on LaSalle Street.

Many of the cottages from the El Verano Motor Court were relocated instead of razed. This is a photograph of one of the surviving duplexes, located near Julington Creek. Built in 1955, this building was larger than the other cottages—perhaps it was the owner's residence. Although it lost one front door, the building still has its original corner windows, porch supports, and tile roof. (Courtesy of Stephen J. Smith.)

Watchful sentinels of San Marco, these three bronze lions have been the centerpieces of San Marco Square since they were unveiled on April 18, 1997. The fountain was created by sculptor Hugh Nicholson and architects Angela Schifanella and Alan Wilson to replace the original 65-year-old fountain. Lions are a symbol of St. Mark, the patron saint of Venice, Italy, and represent both secular and religious power. Lions are also featured at the Piazza San Marco in Venice, the area in Italy that inspired Telfair Stockton when he developed San Marco in the 1920s. Today the lions cast their gaze down the three intersecting roadways of the square, eternally scanning the horizon for whatever changes the future may bring. (Courtesy of Stephen J. Smith.)

www.arcadiapublishing.com

MAP SEARCH

Discover books about the town where you grew up, the cities where your friends and families live, the town where your parents met, or even that retirement spot you've been dreaming about. Our Web site provides history lovers with exclusive deals, advanced notification about new titles, e-mail alerts of author events, and much more.

Find Your Place in History.